PAINTING PARTY
ACRYLIC PAINTING FOR BEGINNERS

NORTH LIGHT BOOKS
CINCINNATI, OHIO
www.artistsnetwork.com

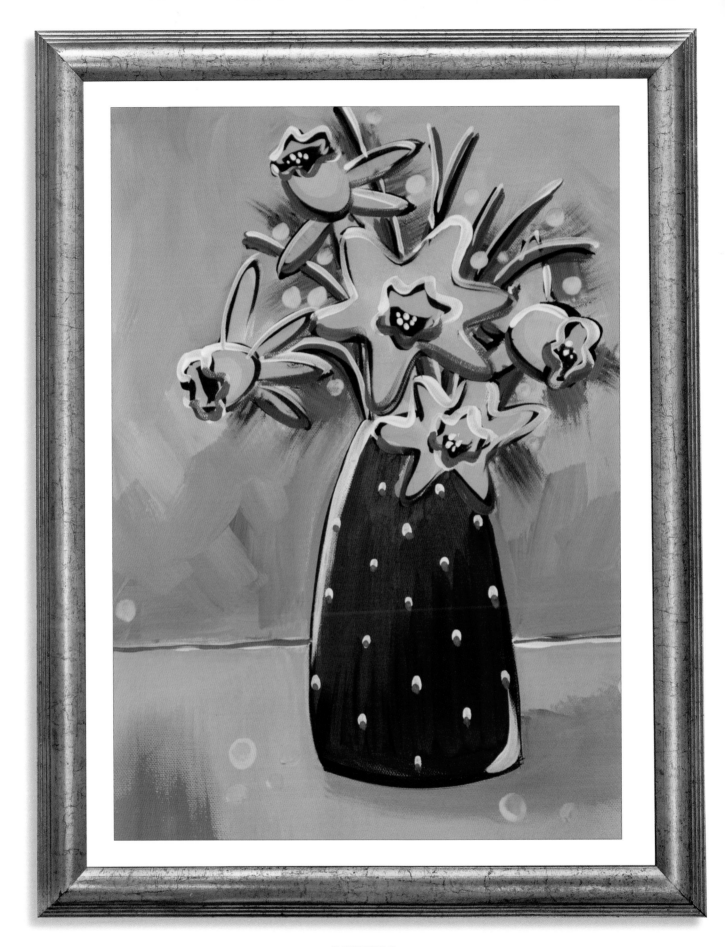

DAFFODILS

Acrylic on canvas

16" × 20" (40cm × 50cm)

PAINTING PARTY

ACRYLIC PAINTING FOR BEGINNERS

Anna Bartlett

CONTENTS

WHAT YOU'LL NEED

Surface
- ❀ stretched canvas

Golden Fluid Acrylics
- ❀ Burnt Sienna
- ❀ Carbon Black
- ❀ Diarylide Yellow (or Arylamide Yellow)
- ❀ Dioxacine Purple
- ❀ Green Gold
- ❀ Hansa Yellow Medium
- ❀ Hansa Yellow Opaque
- ❀ Iridescent Gold
- ❀ Iridescent Silver
- ❀ Jenkins Green
- ❀ Payne's Gray
- ❀ Phthalo Blue (Green Shade)
- ❀ Phthalo Green (Blue Shade)
- ❀ Pyrrole Red
- ❀ Quinacridone Magenta
- ❀ Raw Sienna
- ❀ Sap Green
- ❀ Teal (or Turquoise)
- ❀ Titanium White
- ❀ Ultramarine Blue
- ❀ Zinc White

Jo Sonja's Acrylics
- ❀ Green Light/Permanent Green

Brushes
- ❀ no. 12 flat, nos. 6 and 12 rounds

Other
- ❀ chalk or charcoal
- ❀ gesso (white and black)
- ❀ palette
- ❀ paper towels
- ❀ pencil
- ❀ Soft Gel Medium

PART 2 DEMONSTRATIONS

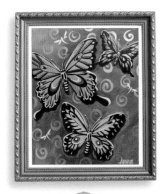

24

BUTTERFLIES

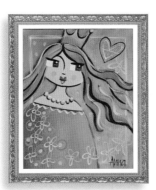

32

PRINCESS

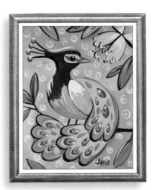

40

PEACOCK

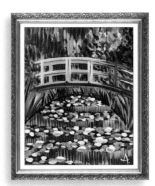

48

MONET'S
BRIDGE

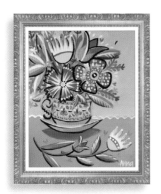

60

TEA CUP &
BLOOMS

68

LOVE BIRD TREE

76

COW

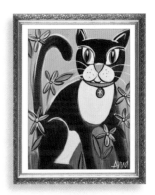

84

CAT

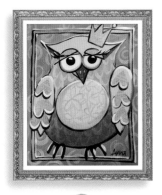

92

OWL

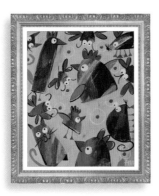

100

MENAGERIE

108

TULIPS

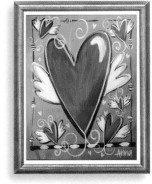

116

FLYING HEARTS

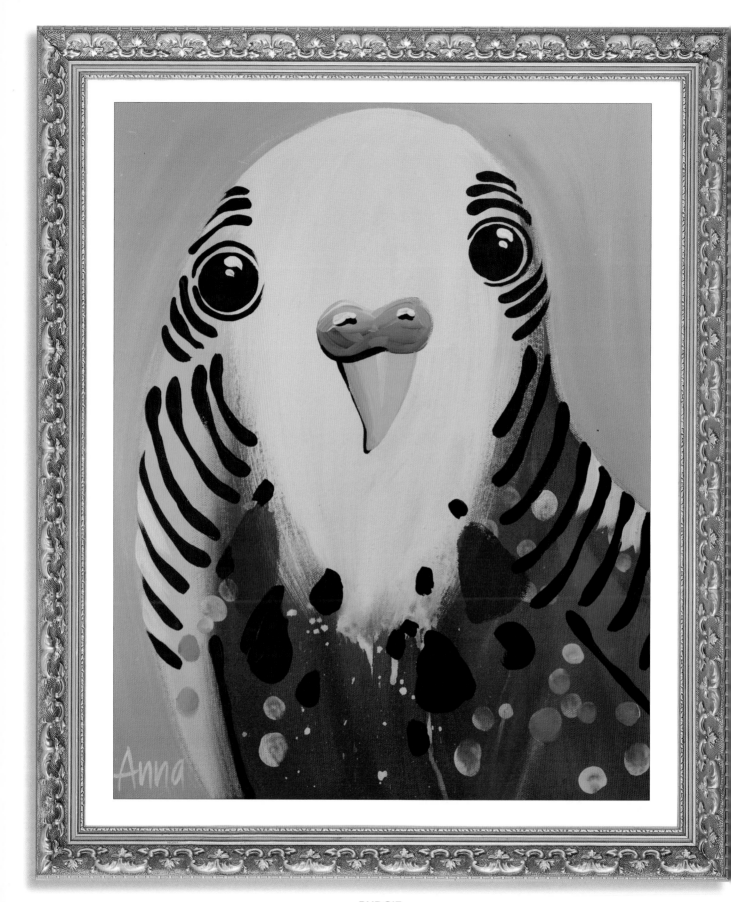

BUDGIE

Acrylic on canvas

16" × 20" (40cm × 50cm)

INTRODUCTION

Hello and welcome! Are you ready to get some paint on your hands—and maybe a little bit in your hair?

Quite simply, I love painting—the colors, the freedom, the joy of all the feelings I welcome as I create "shiny happy art." And every time I see a beginner painter realize that they can do this too, it's a very happy day.

I've been drawing and painting for as long as I can remember. My mother is an artist, so I grew up watching her master various mediums. When I was a little girl, she would give me a bucket of water and a paintbrush, and I'd paint my way down the cement driveway, painting over it again as it dried and disappeared.

Over the years, I've done many paintings experimenting with different materials and styles. I've participated in group shows and sold works online, in galleries and at markets. I've painted commissions, murals and live on stage. People often asked why I didn't teach painting, but I felt unqualified to do so because my degree was in business, not art.

Then I stumbled across the idea of paint-alongs, and I knew this was something I could do! I knew I had the ability to plan out the steps of a painting and explain each step clearly. So, one cool spring evening in 2011, I invited a few friends over, and we painted flowers and butterflies together. I watched closely to get an idea of what beginner painters wanted to know and how long the various stages of a painting would take to complete.

That first session gave me the confidence to really give this a go, and later that year I opened my home studio to host a couple of paint-along groups. From there my little business really started to grow. Today my paint-along sessions fill up within a matter of days, and sometimes within hours. And while I have many regulars (I like to call them my Shiny Happy Graduates) who add new paintings to their collections each term, I still have many beginners joining me to paint their very first shiny happy works of art.

The sheer joy and amazement of helping somebody to produce art that they are proud of is one of the most important reasons I keep doing what I do. I believe everyone is creative in some way. I also understand that as adults, we often place totally unrealistic expectations on ourselves when it comes to making art. But just as you wouldn't expect to be able to sit down at a piano and play Mozart without plenty of practice, you have to give yourself a break when it comes to painting. Your confidence and ability will improve with the help of a good teacher (that's where I come in), but don't be discouraged if you aren't able to produce a "masterpiece" right away. It takes time and practice.

It should also be fun! Painting with a friend is something I always encourage. Over the years I've had sisters, parents and children, extended families and work colleagues come in and paint together. The results have been not only beautiful, but the memories they made are priceless.

It's also important to create art that fits into you life. In order to feel like I've achieved something, I have to be able to start and finish a painting in one session. But with four kids at home, I don't have unlimited hours to devote to a composition. The beauty of the paint-along projects in this book is that they can be completed in a single afternoon, and the result will be a painting that you'll be happy to hang on your wall.

As you work through the projects in this book, you'll notice that I don't spend a lot of time on theory or fancy names for techniques. Rest assured, you will be learning plenty of brushwork and painting techniques as you complete the various projects (in whichever order you choose). But I really want you to be able to simply follow the steps as I show you in order to produce something you love. And if that encourages you to pick up the brush more often and learn a little more each time, then we'll all be shiny happy artists!

BEFORE YOU BEGIN

After running paint-alongs in my studio for more than three years and welcoming hundreds of enthusiastic painters through my big red doors, there are a number of things that I now make sure I talk about at the beginning of every session.

∼ STAY POSITIVE ∼

It's amazing how one person's vocal negativity can bring down the mood of an entire room. I learned early on that I just couldn't let that happen. Even if you're painting alone, I encourage you to stay positive inside your own head. Know that I will guide you step by step, just as I have done with many others. I encourage you to experiment with believing you can learn this! Connect with the child inside that wouldn't hesitate when given a brush and paint. In fact, speak to yourself the way you'd speak to a child. Feel free—it's where I try to live and it's nice over here.

∼ STAY LOOSE ∼

If you haven't actually had two glasses of wine before you start painting, pretend that you have! Be bold. Be confident. Just follow along and don't sweat the small stuff. Do whatever it takes to relax. Shiny happy art isn't meant to be stressful, so if you're not enjoying yourself, step away from the canvas! It's OK if you need to take a break or if today is just not your day to paint.

This stay-loose mantra can extend to your whole body. Be conscious of how much you are moving while you draw and paint. Don't limit yourself to tiny finger movements, holding the pencil or brush the way you were taught at school. Use your wrist, your forearm, your upper arm, your shoulder, even your whole body to make expressive shapes and smooth curves. Using bigger paper and canvases will also help with this.

Try playing music while you paint or leaving the TV on in the background. Experiment with sitting or standing, painting in the morning, painting at night,

inside, outside—try it all! Then you'll have more of an idea about what works for you.

Your happy experience of painting will seep into your artwork. You don't want to look at your art on the wall and think about the stress or tension that went into it. You want to connect it to a wonderful experience, a time that you enjoyed the process and achieved the outcome you desired. That memory of joy is one of the things that makes your artwork really special.

∼ IT'S NOT FINISHED UNTIL IT'S FINISHED ∼

This should help with your positive attitude. Please understand that every painting goes through an "ugly" stage, and we certainly don't stop there. If you were baking and stopped at the messy mixing bowl stage you'd never have a cake. Paintings have many layers, so don't stop and despair before your painting is finished. Trust me to guide you through each step methodically, reserving any judgment at all until it's done. And even then, if you don't like it, take a step back and think about what parts of it are bugging you—then have another go at it!

∼ JUST DO WHAT YOU'RE TOLD ∼

You wouldn't turn up at a yoga class and deliberately not do what the instructor said, would you? That's how it is with these paintings. Think of these projects as recipes. Especially if you're a true beginner, allow yourself the luxury of following the instructions first. Then you can build upon that knowledge to paint the subject a second or third time, experimenting with colors, patterns or additions to make the painting truly your own. All of these painting projects are very achievable in terms of time. So the first time you paint one, make it easy on yourself and simply "do as you're told." Get a real feel for it before deciding whether you'd like to try something new or different. Then do that the second time around. This way you'll build your confidence, and every stroke of the brush will increase your skill.

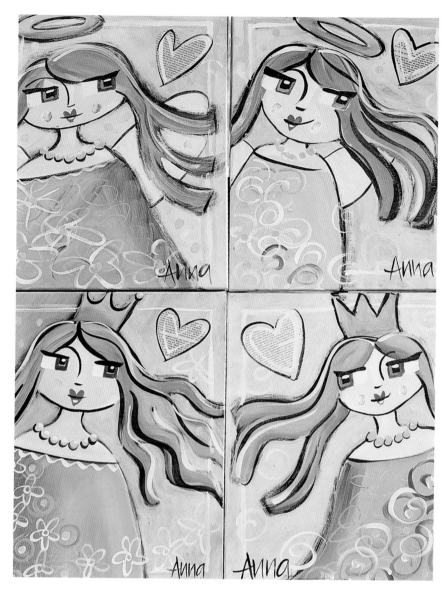

SAME PAINTING, DIFFERENT RESULTS

I like to have a few demonstration canvases out each time I hold a paint-along. Each is one of my versions of the same composition. The aim is to demonstrate that even when the same person paints the same subject more than once, they'll all look slightly different.

∼ AIM FOR SIMILAR BUT DIFFERENT ∼

Shiny happy art is something where "close enough" really can be "good enough." And sometimes it's even better! While you might like what I've painted, I might think that what you've painted is even more wonderful. Whether it's the unique way you load paint on your brush, or whether you're naturally heavy handed or sketchy—your painting should be your own.

Sure, I'm guiding you, but understand that there's no need to paint a carbon copy of what I've done.

Similar but different is the goal. When the ideas and techniques in these painting projects mesh with a person's own experiences, ideas and other influences—it's then that art can become life changing and enhancing.

Supplies & Techniques

I recently read a Facebook post that stated, "There's no greater joy than that of new art supplies." It's like that person lives in my head!

For many years I have loved art shops, craft stores and newsstands. A new pad of paper or a blank canvas is a bundle of potential to me. Every new sharpened pencil could create a masterpiece; every tube of paint, a new discovery; every paintbrush, a new technique.

I also realize that for beginners, art shops and art supply websites can be overwhelming. When you want to get the right tools and supplies, but not waste money on things you don't actually need, the abundance of paints, brushes and canvases out there can seem a bit too much. So I've included plenty of information for you about what I use and why I use it. And keep in mind that while you're in the art supply shop, it's perfectly OK to ask someone to help you if you need some assistance in choosing the right materials.

Also remember that the idea is to simply get painting! Don't let the worry of not having the absolute correct red, or a specific size or type of paintbrush hold you back. You'll simply end up with a similar-but-different result—and that's what we're all about!

For many years I painted on the kitchen table at night after the kids went to bed. My painting supplies had to be simple so I could get them out and put them away quickly. Though I must admit that there were some weeks when I took over the table completely. Dinner on the couch, anyone? But enough of the personal confessions—let's get to the really juicy stuff!

~ PAINTS ~

I love acrylics because I paint fast and they dry fast. They don't smell, and the colors are amazing. If you think of acrylics as pigments suspended in a medium (a little like PVA glue), you'll start to understand why quality is important. Quite simply, the more pigment used in each tube or bottle, the more vibrant the color and, usually, the more expensive the paint.

Generally there are two descriptions of acrylic paints—artist quality and student quality. The beauty of artist quality is that a little goes a long way (unlike cheaper paints that have little to no coverage). There are also more color choices in artist-quality ranges and less color shift (the difference in color from when the paint is wet to when it dries). Usually acrylic colors start lighter and dry a little darker. I always advise to steer clear of the $2 tubes if you can, but buy what you can afford. You can mix and match your brands and colors and experiment to find what works best for you.

PAINT BRAND RECOMMENDATIONS

The best acrylics I've ever used are the Golden Fluid acrylics. They have the consistency of runny cream, they suit my style, and the colors are predictable. Fluids are packaged in groovy little bottles with small openings and hinged lids, meaning they don't dry out too quickly if you forget to close the lids, and you can't drop the lids when you're opening them (I seem to do this constantly when using tubes of paint). Liquitex and Winsor & Newton are fabulous brands too.

Receive bonus materials when you sign up for our free newsletter at artistsnetwork.com.

You won't need a huge selection of paint colors to complete the projects in this book, so please use my palette lists in each project a guide only. You can use similar colors and you'll get similar results that are all your own. Or you can try them with a different color combination. I do recommend that if nothing else, you always buy an artist-quality Titanium White. It is much more opaque than student-quality and will stay white after you varnish your piece. (It's heartbreaking to see your highlights disappear before your eyes as a painting dries!)

When it comes to artist-quality paint, different colors will be different prices. This is because ranges are divided into series, and the more expensive the pigment, the more expensive the paint. Series 1 will usually include whites and blacks, as well as some browns. The Golden range goes right up to Series 9 for some very special colors like Cerulean Blue Deep.

If the word "hue" is in the paint name, it means "imitation." Simply put, a hue paint has been manufactured with a blend of cheaper pigments to make a color that's close to whatever it's a hue of. So the coverage won't be as good, but it will be cheaper. I have some favorite hues of my own, but it's good to know why they're hues before you buy them.

One of the most important things to consider when choosing your paints is whether they are translucent (see-through) or opaque (full coverage). On some brands of paint, you can tell the transparency of a color by the swatch of paint on the label—a big help. In general, opacity is determined by the pigments used in the paint. For example, Carbon Black is actually made from carbon, which is pretty dense. Yellow Ochre is made from ochre, from the earth, and will also have really good coverage. Colors that have fancy, chemical-sounding names like Quinacridone or Napthol are more modern colors and have been produced chemically. These colors are usually more transparent and make very consistent glazes.

The last thing I want to mention about paints is that I use a couple of different whites—Titanium White and Zinc White. Titanium White is probably the white that you're familiar with. It can be applied thickly as a bright highlight. It's fairly opaque (sometimes you might need a few coats, but often

one is enough to achieve stark white), and if you add it to red, you'll get pink.

Zinc White is a white from the Golden range that I like to use, and it's really transparent. In some other brands it may be called Mixing White or Tinting White, if it's included at all. When you add Zinc White to red, you get light red. I really like to use it over dry paint to blend backgrounds and create interesting effects, so look out for Zinc White, as it's really handy to have. If you don't have Zinc White, you can try watering down or adding glazing medium to Titanium White, but it's often a little cloudier than Zinc White, so experiment and see what you think.

QUANTITY VS. QUALITY?

If and when you want to create artwork to sell, and charge reasonable prices, I believe you have a responsibility to use truly artist-quality materials. Until then, please use what you can comfortably afford to throw around without skimping on the amount of paint you're using. Skimping is simply no good for creativity. No good at all! Work towards abundance in your art supplies—it will take some time as you discover the colors and products you like most. But whatever you do, make sure you have enough paint on hand to be generous with yourself.

Visit artistsnetwork.com/paintingparty to download stencil templates and a bonus demonstration.

~ CANVASES ~

Years ago stretched canvases were so expensive. My mother was an artist, and she would paint over her paintings if they hadn't sold within a certain period of time because it was just too expensive to buy a new canvas for every new painting. These days stretched canvases (without frames) are seen on walls everywhere. Companies make them in bulk, and there are huge variations in the quality of the canvas itself, the timber frames and the construction.

The canvas itself is often described by weight and material. Expensive, heavier, acid free, unbleached or linen usually implies higher quality. Less expensive canvases may also have cut corners. I always advise looking for folded corners as they're neater, and if you ever have to remove the frame, it will be easier to re-stretch.

The real beauty of stretched canvases is that they are ready to hang as soon as you are finished painting. Artists no longer have to invest in frames (often a serious investment) for paintings that may not sell. Buyers are no longer paying commission on frames, and if they do decide to frame a piece, they can choose a mount to suit their own decor. For my studio paint-alongs, I use a "professional" student-quality stretched canvas, mainly because of price. I use a brand that has folded corners, and I only use thick-edged canvases because they seem a little less likely to warp.

Most pre-made stretched canvases will also come pre-primed. This means that a coat of (usually white) primer paint has been applied to the canvas during manufacturing. This is usually fine to start painting on, and to save time, we do so in my studio paint-alongs. If you have a bit more time though, I'd recommend adding at least one more coat of gesso yourself.

Gesso is similar to white acrylic paint and prepares your surface for painting. It also acts as a barrier between the canvas and the paint that goes on later. This means that your paint won't soak into the weave of your canvas, and by the same token, any tannins (or similar) that may be in the canvas won't discolor the paint you apply later. Some brands of gesso are thicker than others, and student quality won't have the coverage of artist quality. But in general, gesso is not that expensive, so experiment with a few brands to see which you like best.

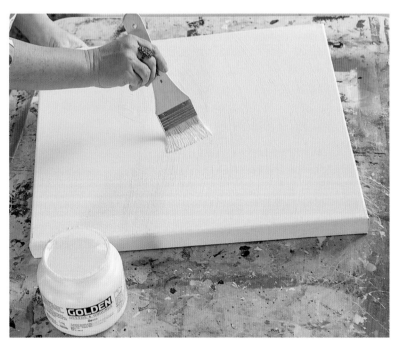

PREPARING A CANVAS WITH GESSO

I try to gesso a few canvases at a time so they're ready for a painting when I am. An extra coat or two of gesso can be the difference between the brush gliding across the canvas and dragging across the canvas. Trust me, gliding is so much more fun!

~ BRUSHES ~

Over the years I have amassed quite a collection of brushes, ranging in price from $1 to $75. (Oh my, that was a special purchase!) But when it comes to my paint-along paintings, I stick to three main brushes: a no.12 flat bristle and nos.12 and 6 taklon rounds.

The no.12 flat bristle brush is really cheap. When new, it will definitely lose some hairs, so keep an eye out for that. But when it's worn in a bit and more "middle aged," it is perfect for what you'll want to do with the projects in this book. Once it's past middle age and the bristles are worn down and hard, then it becomes a perfect brush for collage mediums!

Taklon is a flexible synthetic fiber. These brushes start off white (they do stain pretty easily) and tend to hold their shape well when used with acrylics. I spend about $6 on the no. 6 and $10 on the no.12 to give you an idea of how affordable they are.

BRUSH CARE

It is important that you look after your brushes by:

- ✿ always loading your brush from the edge of your puddle of paint
- ✿ loading your brush by stroking from the puddle
- ✿ letting the handle of the brush lead the way when painting lines (never splitting the bristles by forcing them back on themselves)
- ✿ washing your brush out in a water well
- ✿ laying your brush down on a paper towel or piece of paper between uses (if left in water, the bristles bend and wooden handles can swell)

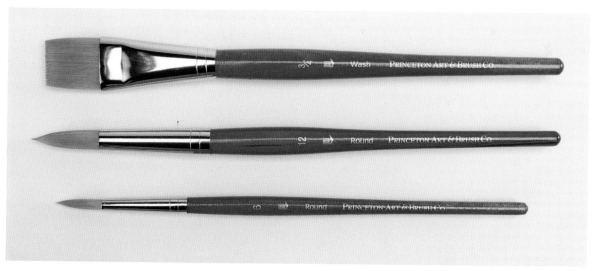

BRUSHES YOU'LL NEED

From top to bottom:
- ✿ *no. 12 flat*
- ✿ *no. 12 round*
- ✿ *no. 6 round*

Whether you've got a special area that's all yours or your space is more of a "pop-up" than a permanent setup, there are a few things to consider when setting up your immediate area.

If you use a smaller canvas, you might not need an easel, but if you are using a larger canvas of about 16" x 20" (40cm x 50cm) or larger, you might want to invest in your own tabletop easel at some stage. In the meantime you can prop your canvas up on something—working on an angle can really help you fill up the space more easily.

I'm right-handed, so on my right side I'll lay down an old tea towel for drying my brushes. I also place an ice cream container, about two-thirds full of water. I find if there's any less than that, the water gets too mucky too soon, and I like to be able to finish a painting without having to change my water.

I use a tear-off paper palette. (Sometimes I use two— I like to think that it makes me a more exciting artist when one palette simply isn't enough.) I also lay out the brushes I plan to use, as well as chalk or charcoal for lines if needed.

Another very important thing to consider when setting up your space is light. Depending on the time of day you are painting, and whether or not you have a source of natural light, it's often good to have at least a desk light to shine on your work. There are special "daylight" bulbs available, but they can be pricey, so just use what you have at your disposal and remind yourself "similar but different" is what you're after anyway.

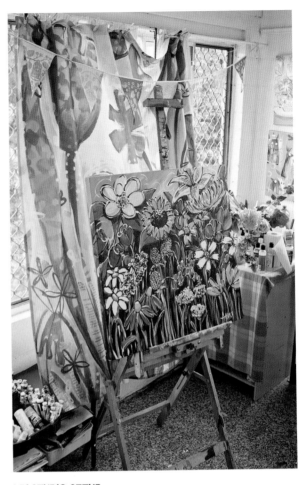

MY STUDIO SETUP

It's an absolute luxury to have my own studio—a space where I can leave a project out on the easel, ready for me to come back to—but it hasn't always been this way. I remember making art on the corner of my desk while in high school, on the floor while at college, and on the kitchen table while my children slept. I know what it's like to have to pack up all your stuff so inquisitive little hands don't get into your precious art supplies and to have to keep your best supplies stored up really high. So just keep in mind that wherever and however you have your workspace set up can always change later as you progress with your artwork.

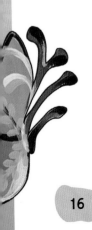

BASIC TECHNIQUES

When I first started planning paint-alongs, I tried to add in a new technique as often as possible. So in the projects I've included in this book, you'll be able to try using collage, painting wet-into-wet, using stencils, and experimenting with "Beginner's Impressionism." You'll also learn about how wonderful and non-repeatable negative-space paintings can be.

As part of our staying-loose plan, there is no need to mix a perfect color before putting paint to canvas. When painting with a mixed color, load the brush with the lighter color first, then pick up just a little of the second color from the side of the puddle of paint, allowing the colors to blend when they're actually applied to the painting. If it's too dark, load the brush with the lighter color and vice versa.

∼ LOADING THE BRUSH AND BLENDING ON THE CANVAS ∼

Many absolute beginners make the mistake of dabbing in the middle of their paint puddles when loading their brushes. But this approach doesn't actually load the bristles well or leave the palette free for creating different colors during the painting process. So I encourage all my students to load their brushes by stroking from the side of the puddle. You'll notice the extra control you have over the marks your brush is making.

∼ BEGINNER'S IMPRESSIONISM ∼

In a nutshell, Impressionism is putting down marks of freely brushed colors that optically blend to make a lively new color when viewed from a distance. Attempting Impressionism can feel a bit intimidating for beginners, but I encourage you to just look at it for what it is—simple mark making. Trust in the process, trust that you understand what it is you're painting (trees, water, the water's edge, etc.), and it will all come together in the end.

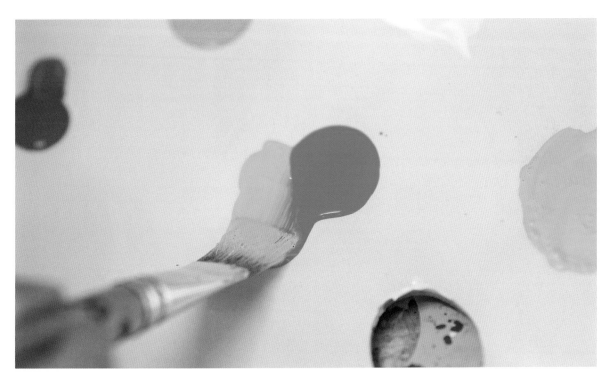

LOADING WITH EXTRA COLOR

I love adding an extra color on one side of a flat brush and letting the stroke be naturally streaky. (Using green and yellow at the same time on your brush is great for leaves and greenery.)

∿ USING STENCILS ∿

Some artists might think of using a stencil as cheating, but I'm happy to put it down to being resourceful. I don't use store-bought stencils very often. But I like to build up layers, and sometimes those store-bought patterned stencils, or even the holey bottom of a pizza tray, can really do the trick.

I do use homemade stencils in my projects though. (We'll be using homemade stencils in the Butterflies painting project later.) If you have any worries about being able to draw the shape you want, put them to rest. You can simply print out the image you want to make a stencil from at the size you want, then laminate that sheet and cut out the shape with a craft knife. These stencils won't last forever, but they will certainly do the trick if you want to save some time and your sanity.

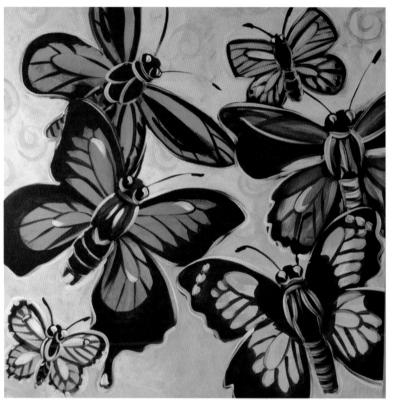

BUTTERFLY PAINTING WITH STENCILS

I painted this group of butterflies as a birth gift for my third child, and it inspired the paint-along you'll find later in this book. In my beginner paint-alongs however, I found that drawing the butterfly shapes often sucked up the bulk of the session. To ensure we could finish in time, as well as focus our energies on the colorful wing patterns instead of the wing shapes, I created some butterfly stencils in different shapes and sizes. They also help you visualize how to layout your composition before you commit to painting it. You can download these stencil templates at artistsnetwork. com/paintingparty.

INVEST IN A LAMINATOR

If you plan on using a lot of homemade stencils in your art projects, you'll want to invest in a laminator. They are relatively cheap, and the time you'll save is well worth it.

Receive bonus materials when you sign up for our free newsletter at artistsnetwork.com.

∼ PAINTING WET-INTO-WET ∼

The name is a bit of a giveaway. Painting wet-into-wet involves applying layers of wet paint over previous layers of still-wet paint. Unlike painting wet-into-dry, which produces sharp edges, wet-into-wet painting allows your colors to spread into one another, giving soft edges and blending. This method does require that you work fast because the entire painting must be finished before the first layers placed have dried.

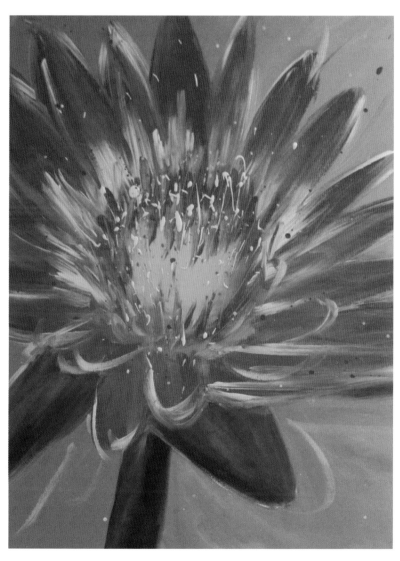

MY FIRST WET-INTO-WET PAINTING

My very first wet-into-wet painting was of a flower that was inspired by a photo on a tissue box. My husband had just finished our bathroom renovation, and as a result, there was an empty wall above the bath that really bothered me. But I only had about 30 minutes to finish the painting because visitors were coming for dinner, so I had to be quick!

I painted the shapes, blocked in the background colors and used my fingers to blend a few tones of purple and white into the blue. For the petals, I used a large brush to block in the color. Then while it was wet, I added white from the center, stroking in the direction the petals would be growing. Because I was enjoying this frenzy of paint application so much, I finished the piece off by splattering some fluid paints using the end of my paintbrush.

That painting still hangs in our bathroom today. While there are definitely some things I would do differently if I were to paint it again, my happy memory of that experience has me painting wet-into-wet very often these days.

⌒ COLLAGE ⌒

While I would not consider myself a mixed-media artist, I am always looking for ways to make my art more special. Sometimes a bit of collage is just the thing. But keep in mind that some papers and fabrics you'll want to use for collage might not be acid free, meaning they will fade and deteriorate over time. This can be a problem if you're aiming to end up with a quality, saleable artwork.

When using a collage material, ask yourself whether it will fade or buckle easily. If you don't know the answers to these things, that's fine, but perhaps don't sell that piece. Keep it for yourself, or scan it and reprint with stable inks.

Fading is obviously something that's hard to test ahead of time, so just use your common sense. If you're using a page from inside a book, it might fade, but that might not bother you too much. Generally the color from the text on book pages won't bleed, but this is something you can test beforehand. Patterned or colored paper napkins are also wonderful for collage.

When adding collaged paper or fabric to your paintings, I recommend using Soft Gel Medium. If you can't get hold of this product or are just experimenting with the idea of collage, you could use a slightly watered-down PVA glue solution or Mod Podge.

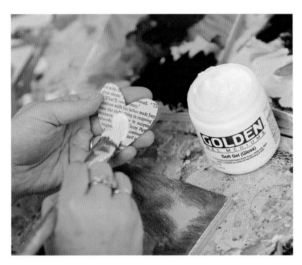 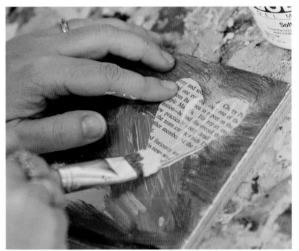

APPLYING SOFT GEL MEDIUM

Completely coat both sides of the paper in Soft Gel Medium (or Mod Podge or watered-down PVA glue). Brush on a layer of Soft Gel Medium on the back of the paper, then totally cover the surface of the piece you've just added with another coat of gel medium. It's protected then, and your subsequent brushstrokes will push the paper into the first layer of medium, preventing buckling.

You then have a couple of choices for the collage. You can leave it as is with the clear coating of medium, or you can paint over the top of it. There are projects that use both of these methods included in this book.

∼ POSITIVE AND NEGATIVE SPACE ∼

One wonderful way to approach paintings is to first let loose on the canvas with color and marks, then mark out the positive shape of the subject of your painting with chalk. Then paint out the negative space (all the space other than the subject—the air space) with another color. The Menagerie painting project later in this book is a perfect example of this.

The other beautiful thing about this approach is that if you truly let loose on the canvas and experiment with marks and colors, there's pretty much no way that painting could be painted exactly the same way ever again. So even though we're all setting out to paint the same thing, the end results will be hugely different. And that's wonderful, isn't it?

DECIDE ON YOUR SHAPES

Let your colorful canvas or board dry and then mark out some shapes with chalk. I like using chalk because the next coat of paint usually seems to soak it up, or it can be easily wiped away at the end.

PAINT YOUR NEGATIVE SPACE

Negative space is like the "air space" around an object. If your first layer of color was dark (like mine was), you'll need a light color for your negative space. By the same token, if your initial colors were light tones, you could use a dark color or two for your negative space.

COLOR YOUR NEGATIVE SPACE

Sometimes I choose to leave my background white, but other times I like to include a third layer of paint and add colors to the background. The Titanium White that I used here means that translucent colors, like the yellow in this case, will stay clean and bright. I don't like to make the paint too thick at this stage. If possible, I like to still be able to see a suggestion of the layers underneath.

Visit artistsnetwork.com/paintingparty to download stencil templates and a bonus demonstration.

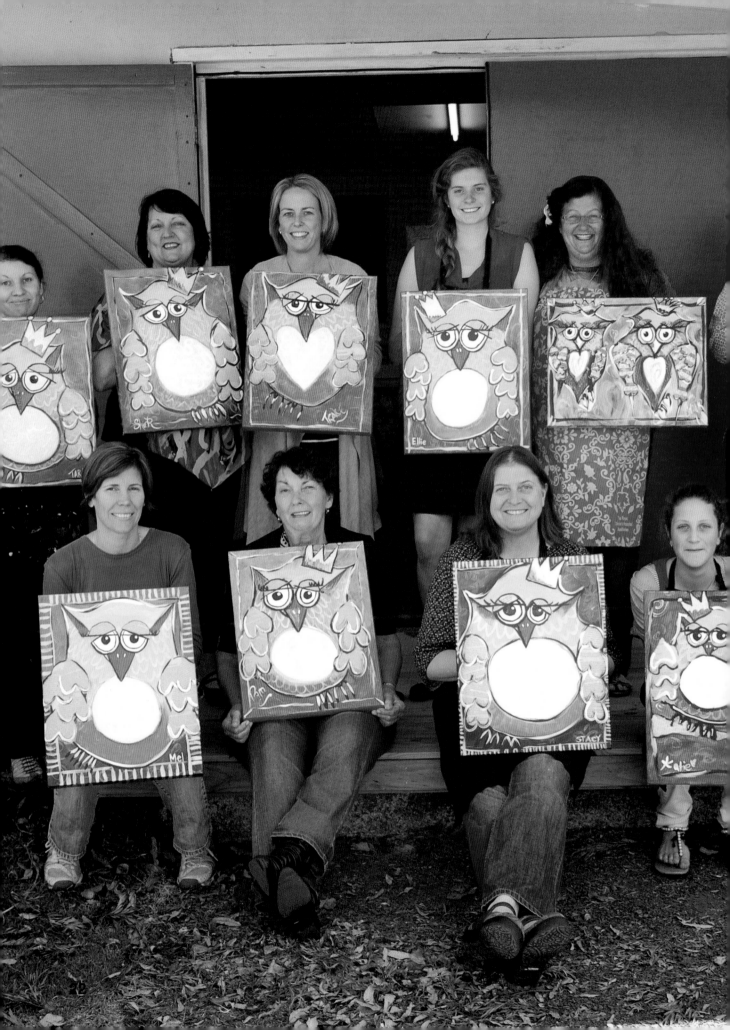

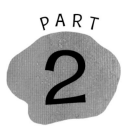
Shiny Happy Painting Projects

Now it's time to paint! At the start of my studio paint-alongs, I put on some boppy music, welcome everyone in with a smile and ask them to sit down at tables I have set with easels, canvases, water buckets, old tea towels and paper palettes. I invite them to get comfy and rearrange things if they want. I also ask them to fill up their water buckets—that activity helps to get the conversation started and gives any stragglers a few more minutes to arrive.

This routine has evolved over the years, and now I'm very relaxed as I begin a new session. While I love public speaking, the adrenaline often takes over, and I struggle to control my nerves. But it's totally different in my studio. I feel so comfortable running paint-alongs and coping with any new angles my beginners try out. I even surprise myself sometimes!

So I hope you feel the warmth of my welcome as you paint these artworks in your own home. Whether you're painting alone or with friends or family, this is special time. I have tried to spell out everything for you as clearly as I can to make it as easy as possible. I'll even tell you when to wash and dry your brushes!

If there's truly such a thing as a runner's high, then I have to confirm that there is also a painter's high. And when you feel it, you know what you're striving for. And that wonderful feeling is my wish for you. So paint, paint, paint!

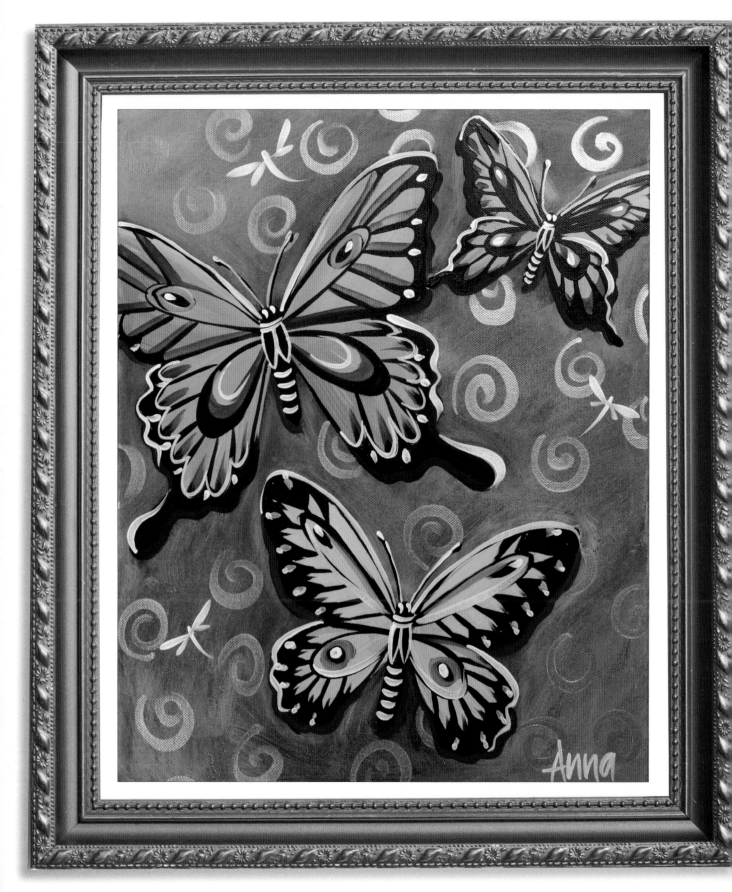

BUTTERFLIES
Acrylic on canvas
16" × 20" (40cm × 50cm)

BUTTERFLIES

Butterflies were one of the very first paint-along subjects I shared with the public. I had a terrific old book on butterflies that my father bought for me, and after going on a butterfly bender for a couple of years, I figured out a way to paint butterfly wing patterns that I call "butterflication." After that, I felt really comfortable sharing my process.

What I hadn't realized is how wonderful this subject is for teaching beginner painters. While the shapes are all so similar, the opportunity to use your own selection of colors and to add as many details as you like means that each person is able to take home a unique artwork different to all the others painted in the session.

I decided to use stencils with this project because I've found that they tend to help beginners get their compositions onto the canvas quickly and free them up to have the confidence of knowing their composition is likely to work.

In this step-by-step demonstration, we'll use both parts of the stencil—the butterfly shape itself, as well as the hole where the butterfly was cut out. So remember to save both. You can purchase butterfly stencils at most arts and crafts stores or make your own. You can download the stencil template I created for this project at artistsnetwork.com/paintingparty.com.

MATERIALS

Surface
- ✿ stretched canvas, 16" × 20" (40cm × 50cm)

Golden Fluid Acrylics
- ✿ Carbon Black
- ✿ Dioxazine Purple
- ✿ Hansa Yellow Medium
- ✿ Iridescent Silver
- ✿ Payne's Gray
- ✿ Quinacridone Magenta
- ✿ Titanium White
- ✿ Ultramarine Blue
- ✿ Zinc White

Brushes
- ✿ no. 12 flat
- ✿ nos. 6 and 12 rounds

Other
- ✿ black gesso
- ✿ butterfly stencil
- ✿ palette
- ✿ paper towel
- ✿ water

BUTTERFLICATION TEMPLATE

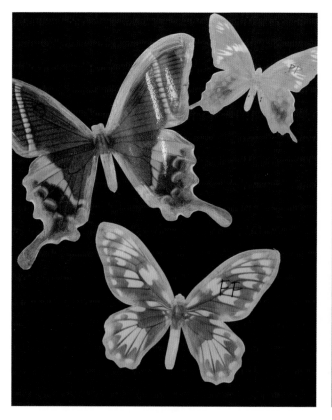

Prepare the Surface and Position the Stencils

Paint the entire canvas with black gesso using a flat brush. Once the gesso is dry, position your butterfly stencils in an arrangement of your choice. Try to vary the angles slightly— you probably don't want them flying "in formation" across your painting!

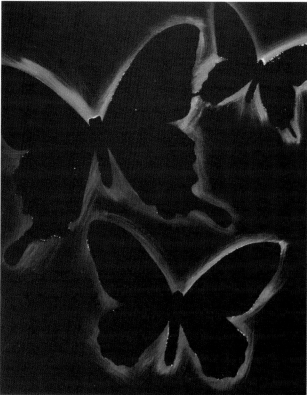

Paint Over the Stencil Edges

Using a small amount of Zinc White on a dry no.12 flat, very lightly paint over the edges of each stencil—you don't want any hard edges. If you have put too much paint on the canvas, wipe it off with a paper towel. If you don't have Zinc White, you can use Titanium White. The color will be more opaque, but you will still get a pleasing result. Wash and dry your brush.

Receive bonus materials when you sign up for our free newsletter at artistsnetwork.com.

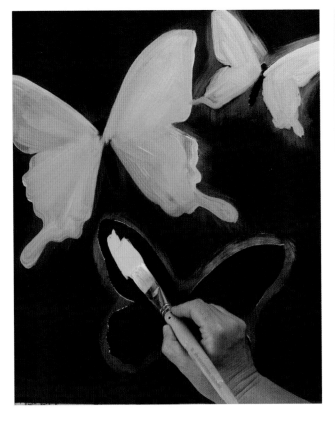

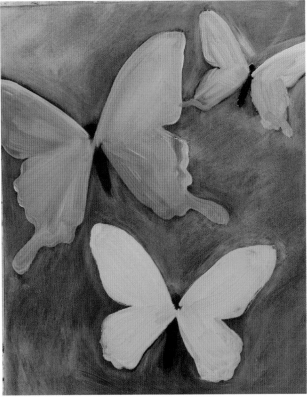

3

Fill In the Shapes

Still using your no.12 flat, fill in each butterfly shape with the color of your choice. (In this example I mixed Titanium White + Quinacridone Magenta to make pink, Titanium White + Ultramarine Blue to make a sky blue, and Titanium White + Hansa Yellow Medium to make an opaque yellow.) While you can use any color you wish, I do recommend that beginners use pastel-toned colors for this step.

4

Lay In the Background

Make sure that your no.12 flat is really dry, then pick up a small amount of Zinc White (or Titanium White if you don't have Zinc White) and start filling in the background. If the paint bleeds on the canvas, your brush is too wet—wipe it off, dry your brush and try again. Try to vary your strokes so there is no obvious outline around the butterflies. If you used Zinc White, you can choose to do just one coat for a darker background or add a second coat to make your background lighter. If you used Titanium White, you won't need a second coat. Depending on your composition, choose two corners and add a small amount of Quinacridone Magenta to one corner and Hansa Yellow to the opposite corner. Blend with your fingers or a paper towel if necessary. These extra colors are optional, but I feel they add just a little more oomph to the painting.

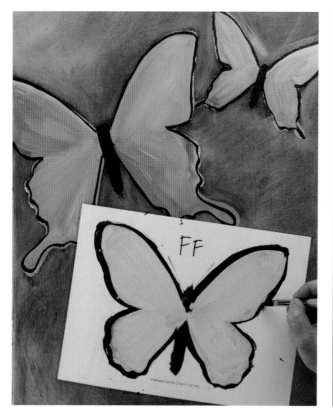

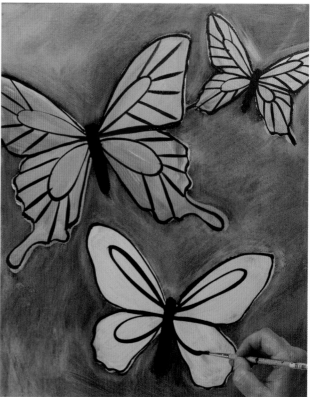

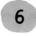

5

Outline and Fill In

Using the outside part of the stencils and your no.12 round, load up with some Dioxazine Purple and very lightly outline each of the butterflies. It's incredible, but very often I find that the shapes don't match up exactly. It's an unexplained phenomenon! But don't worry—you can correct the outlines later. Once you have finished outlining the butterflies, use that same brush to fill in their bodies with Dioxazine Purple.

6

Mark Your "Butterflication" Lines

Now, using the outlines provided, you can mark your "butterflication" lines with a no.12 round and Dioxazine Purple. First, paint the "crossbar" across each butterfly. Then paint in the four "bubbles," one on each top wing and bottom wing. Make them as symmetrical as possible. Finally, paint the "rays" that radiate out from each "bubble." Remember, they don't radiate around like a sun, but rather head out from the body of the butterfly.

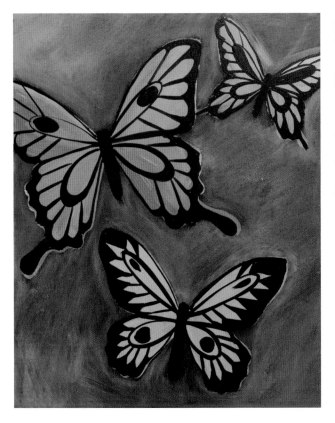

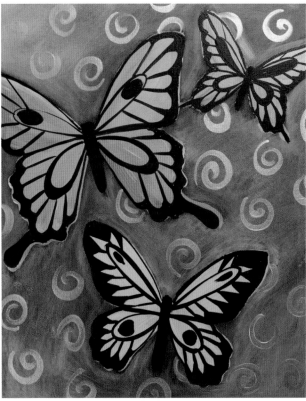

<div align="center">7</div>

Detail the Wings

Add some detail on each segment of the wings. You can add V shapes or U shapes. You can thicken some lines or add circles in each of the bubbles. Try to stay symmetrical and feel free to use real-life butterfly images as examples. I strongly recommend that beginners make up their own designs, though, because then there's no wrong or right.

<div align="center">8</div>

Pattern the Background

Load your clean, dry no.12 round with Iridescent Silver and paint a pattern of swirls across the background of your painting. Imagine it is like wallpaper, so some of the swirls will peek out from behind the butterfly wings, and others will go off the edge of the painting. Wash and dry your brush.

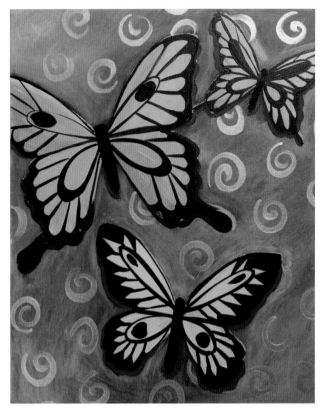

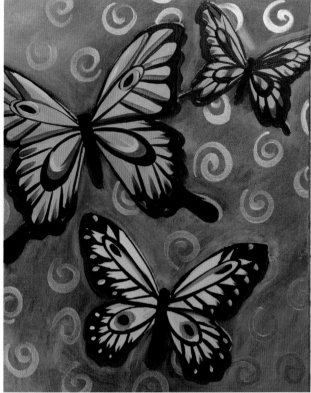

Add Shadows

Load the same brush with a little Titanium White and some Payne's Gray. Paint shadows on the low side of each of the butterflies. Imagine that the sun (light source) is coming from the top of the canvas, which means that the underside of each of the wings would have a shadow. Wash and dry your brush.

Continue Adding Details to the Wings

Add more markings to each of the wings. Using the main color you mixed your pastel color from earlier, add straight Quinacridone Magenta markings to the pink butterfly and straight Ultramarine Blue markings to the light blue butterfly, etc. Once you have finished all three, add a bit of Quinacridone Magenta to the yellow and blue butterflies, some blue to the pink and yellow butterflies, and some yellow to the blue and pink butterflies. This will tie your composition together nicely. And don't forget—you can add dots on top of any areas of solid Dioxazine Purple to create a pattern!

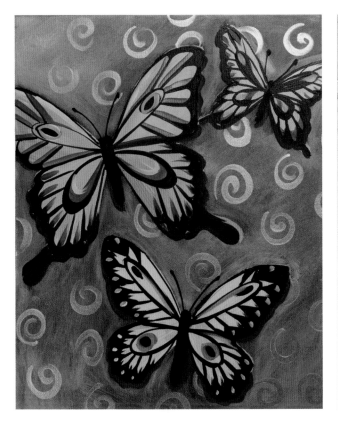

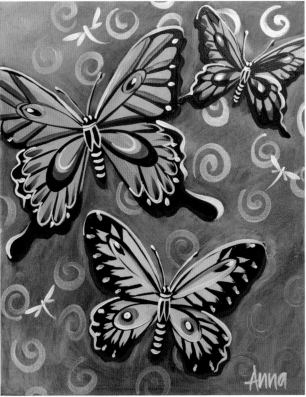

11

Paint the Antennae

Use your no. 6 round and Dioxazine Purple to add thin antennae to each butterfly. The tips of each antennae should have a small bump, approximately the size of a Tic-Tac. Wash and dry your brush.

12

Add Final Details to Finish

Load your brush with Titanium White and add final details to each butterfly body. Paint two apostrophes for eyes, two curved lines below the head, a W to indicate the thorax and a series of parallel curved lines to show the roundness of the abdomen. Mark highlight lines on the upper side of each butterfly and antennae. Add extra dots if desired. If you like, paint an odd number of small white dragonflies in the background. Sign your name—you're done!

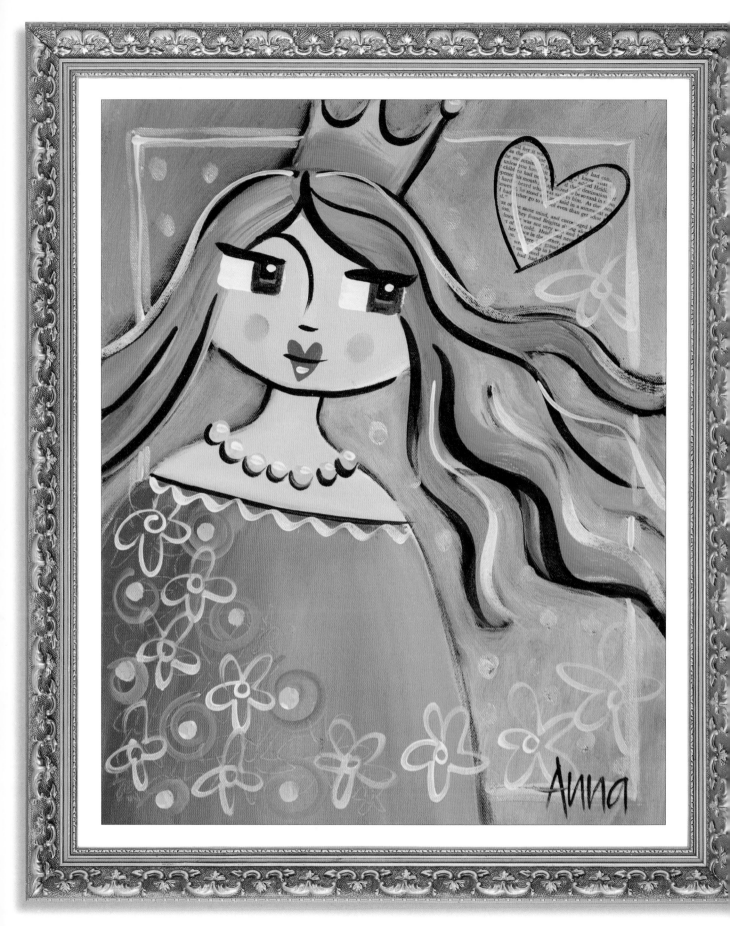

COLLAGE PRINCESS

Acrylics on canvas

16" × 20" (40cm × 50cm)

PRINCESS

For so many years I wouldn't attempt even simple faces because I was unable to figure out how to paint skin tones or get eyes right. Then I saw some of Ken Done's figures. He used a huge variety of colors for his skin tones—some were red, some yellow, some orange and black. For me, it was a blinding flash of the obvious: I could do whatever I wanted! So I did.

In this painting project, you will learn how to mix colors to create a simple skin tone, how to build a lightly layered background and how to collage an unpainted shape into your image. I will also show you a simple method for building a face using shapes, highlights and lines to create a unique character of your own.

MATERIALS

Surface
- ✿ stretched canvas, 16" × 20" (40cm × 50cm)

Golden Fluid Acrylics
- ✿ Carbon Black
- ✿ Hansa Yellow Opaque
- ✿ Iridescent Silver
- ✿ Pyrrole Red
- ✿ Quinacridone Magenta
- ✿ Raw Sienna
- ✿ Titanium White
- ✿ Ultramarine Blue
- ✿ Zinc White

Brushes
- ✿ no. 12 flat
- ✿ nos. 6 and 12 rounds
- ✿ old flat brush (for collage)

Other
- ✿ chalk or pencil
- ✿ book pages (for collage)
- ✿ palette
- ✿ paper towel
- ✿ scissors
- ✿ Soft Gel Medium
- ✿ water

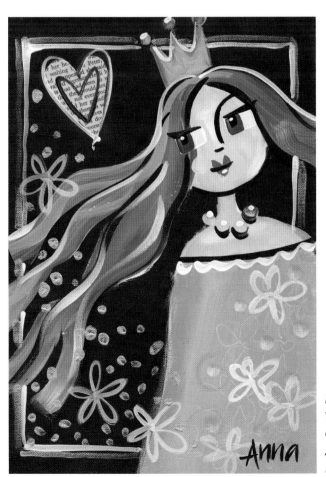

PRINCESS WITH FLIPPED COMPOSITION AND ALTERNATE PALETTE

1

Sketch the Composition

Outline the head, neck, body and crown with a pencil, chalk or paint. You can play around with the proportions of the head (make it a squashed oval like mine, or round, or thinner), the length of the neck and even which side of the canvas the princess is leaning toward.

2

Lay In the Background

Using your no.12 flat, fill in the background with Carbon Black. You don't have to be too perfect here, just get right into it. Use your brush to add some wavy hair, but make sure the area where the hair joins the head is not too thick. Paint around the sides of the canvas too. While this stage is drying, wash and dry your brush. (You might want to refresh your water also to get rid of all the black.)

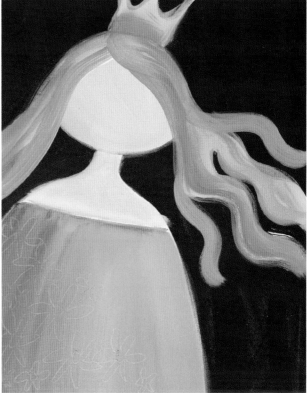

Paint the Dress

Continue using the no.12 flat to mix Titanium White + Quinacridone Magenta (or the color of your choice) and paint in the dress. Work quickly so you can use the end of your brush to scratch a floral pattern into the paint on one side of the dress while it's still wet. Then without washing out your brush, pick up a little bit of Hansa Yellow Opaque and add an accent stripe down the side of the dress that doesn't have the floral pattern. Blend it with your fingers if you like.

Wash and dry your brush and then mix Raw Sienna + Titanium White to make a skin tone. Paint in the head and shoulders.

Paint the Hair and Crown

Load your clean, dry no.12 flat with Hansa Yellow Opaque on one side and Pyrrole Red on the other. Try not to fuss too much with these strokes—keep that lovely blend that comes straight out of the brush. If her part is off center as in this version, you can add extra tendrils (over the black background) if you wish. Once you have painted the hair with yellow and red, add some Raw Sienna and Titanium White to your brush and touch up further.

Wash and dry your brush, then paint the crown with Hansa Yellow Opaque. While it's still wet, blend some Pyrrole Red into the bottom of the crown near the hair.

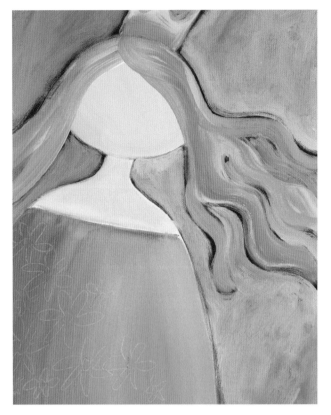

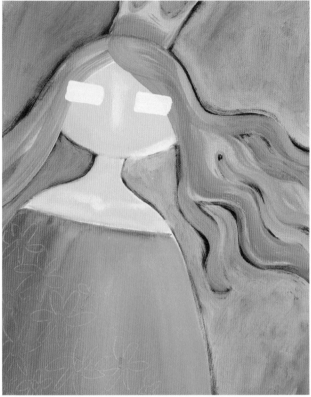

5

Add Color to the Background

Mix a light blend of Titanium White + Ultramarine Blue and lightly scumble the paint to color the background, making sure you can still see some of the black through the mix. Wash and dry your brush.

6

Begin the Eyes, Nose and Collarbone

Use your no.12 flat to paint two white rectangles (with an approximate ratio of 1:2, i.e. like two squares joined together for each eye), approximately halfway down the head. There should be about the width of an eye between them. The size and placement of the eyes will be a big part of what gives this princess her character. One eye (or possibly both, depending on how you have painted her hair) should go over her hair. The line of the eyes is the same as the tilt of her head. Add a second coat of white to make these rectangles totally opaque if needed. Then lightly paint a line between the eyes for the nose and use your finger to smudge it up into the forehead. Add white to the right cheek and also the collarbone and blend both with your finger.

Receive bonus materials when you sign up for our free newsletter at artistsnetwork.com.

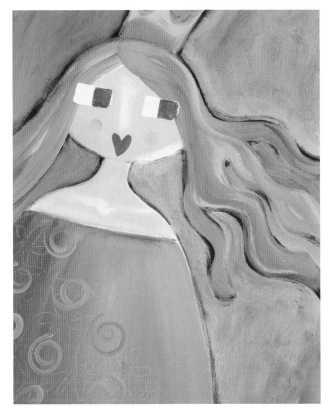

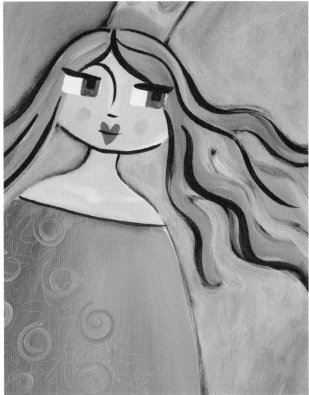

7

Paint the Lips and Cheeks and Continue the Eyes

Use your no.12 round to press and pull a tight V to make a heart shape for the lips. Then use your fingers to smudge a pink cheek mark under each eye using a blend of Titanium White + Quinacridone Magenta.

To add detail to the composition, continue using the no.12 round to add a light blue mix (Titanium White + Ultramarine Blue) as swirls on the dress (around the scratched flowers). Add a stripe of blue to her hair as well. This will connect both halves of the picture and make the composition work better.

Now you can choose the color eyes you'd like your princess to have—I chose blue for this example. Paint in a blue square on one side of each white rectangle as irises. Just remember that whichever side you choose is the direction she will be looking.

8

Continue Building Up the Face

Still using the no.12 round, add Carbon Black outlines to the top of the dress and under her chin, her hair and her nose (this is a small horizontal line directly above her lips, centered on her face). Add a line through her lips (a gentle curve will indicate a smile), along the top of the eye rectangles (make this line heavier at the outsides of the face to indicate lashes) and a single eyebrow/nose line. This should go from above the left eye down the left side of the nose—lift the brush off the canvas to gently end the line. Then add a black square in the middle of the iris, attached to the eyelid line, to indicate the pupils. Wash and dry your brush.

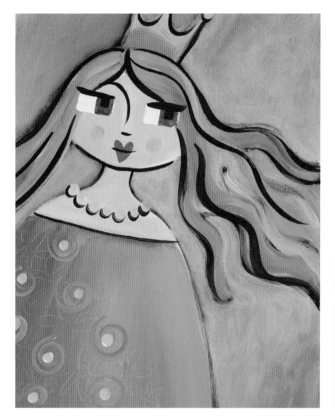

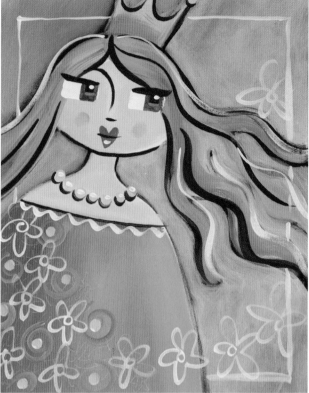

Continue the Background and Add Details

Use a clean, dry no.12 flat to scumble a light coat of Zinc White over your background color. This will add further interest and dimension to the background. Wash and dry your brush.

With your finger, mix some Titanium White + Hansa Yellow Medium and add fingerprints to the center of the swirls on the dress, the tips of the crown and to make a beaded necklace.

Switch to a no.12 round and add a Carbon Black shadow underneath the yellow finger-printed necklace that you've just added. Wash and dry your brush.

Add Highlights and Flowers

Using Titanium White, paint highlight lines and marks for eyes, hair, yellow fingerprints, bottom lip and the neckline ruffle. Add some white flowers to her dress that continue into the background and one flower shape above the tendrils of her hair. Add a white painted border, about an inch in from the edge of the canvas, but only on the background—don't paint a border over the hair or dress. Wash and dry your brush, then add a stripe of a lighter shade of the eye color (Ultramarine Blue + Titanium White) underneath the black pupil.

Receive bonus materials when you sign up for our free newsletter at artistsnetwork.com.

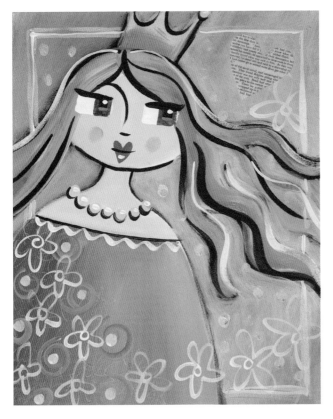
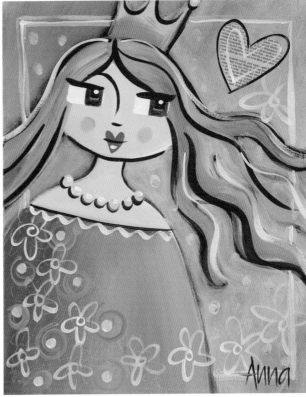

11

Add the Collage Heart

Cut out a heart shape from an old book. Use an old flat brush and Soft Gel Medium to adhere it to the top right side of the canvas. Then coat the entire top of the collaged heart with Soft Gel Medium as well. You don't want any creases or loose edges. (Essentially you're completely enveloping the paper in medium so no air will get in or out once it's dry.)

Add two lines of Iridescent Silver paint, one on each side of the white border. Then use your finger to add some silver dots to the background.

12

Add Final Details to Finish

Using your no. 6 round, touch up any lines that need neatening and add a loose black outline to the collage heart. Finish with a white heart shape on top of the collage paper. Check that all your highlights are white and bright enough and touch up if needed. Now sign your name—she's finished!

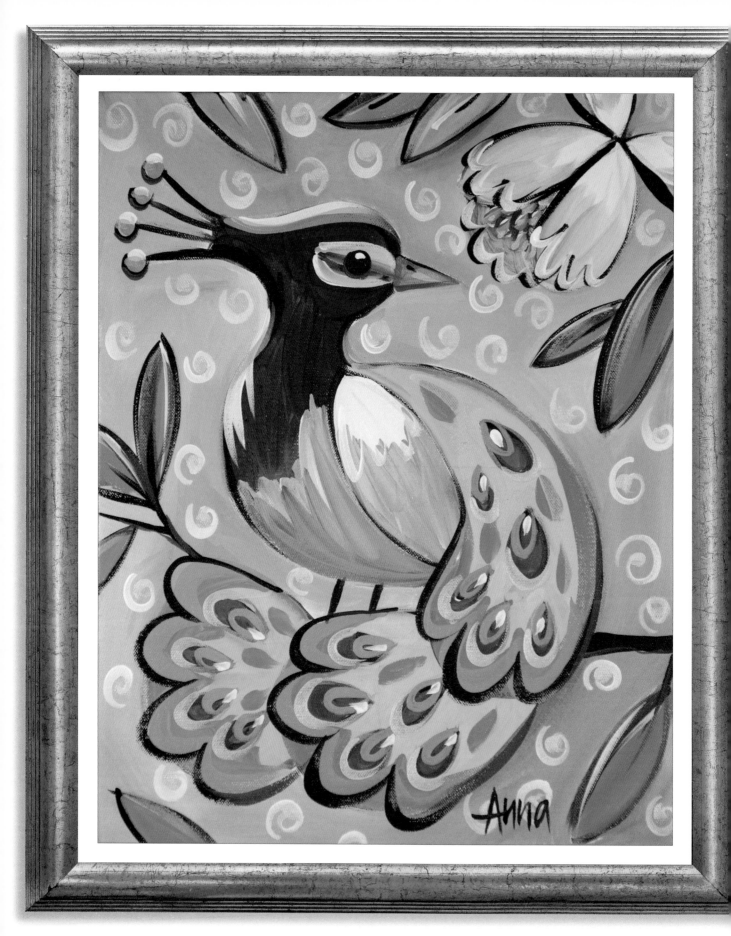

PEACOCK

Acrylic on canvas

16" × 20" (40cm × 50cm)

PEACOCK

Back in 2012, I was walking past a curtain shop on our main street, and they had covered a wall in their display with this wonderful peacock fabric. It caught my eye, and I snapped a quick photo on my phone.

That fabric wall planted the seed of an idea to paint a colorful mural in the corner of my studio. Armed with my reference photo and some paint, I finished the mural on New Year's Eve 2012.

The mural was a hit with my students, so I composed this painting based on it. This is one of my favorites because it builds nicely—it starts with painted outlines, includes wet-into-wet blending and combines bright color mixes with a neutral gray background.

MATERIALS

Surface
- ✿ stretched canvas, 16" × 20" (40cm × 50cm)

Golden Fluid Acrylics
- ✿ Carbon Black
- ✿ Hansa Yellow Opaque
- ✿ Iridescent Gold
- ✿ Phthalo Blue (Green Shade)
- ✿ Phthalo Green (Blue Shade)
- ✿ Payne's Gray
- ✿ Pyrrole Red
- ✿ Teal
- ✿ Titanium White
- ✿ Ultramarine Blue

Brushes
- ✿ no. 12 flat
- ✿ nos. 6 and 12 rounds

Other
- ✿ chalk or pencil
- ✿ palette
- ✿ paper towel
- ✿ water

THE INSPIRATION MURAL

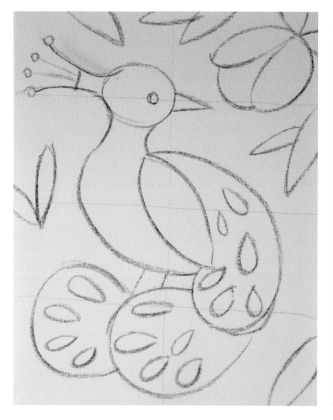

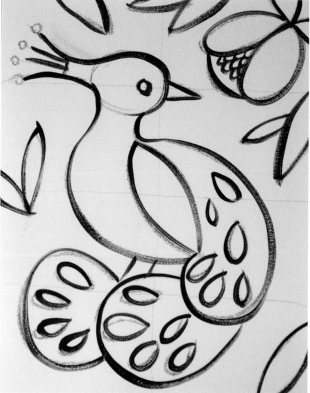

Sketch the Composition

Using pencil or chalk, divide your canvas (or paper) into eighths, then lightly draw the outline of the peacock as shown. Note that the oval head shape cuts through the first horizontal line, and the widest part of the beak is in the center of the canvas. The leaf-shaped wing is on an angle right in the middle of the picture, and the teardrop shapes are at the bottom of each tail tier. The tail comes very close to the bottom and left side of the canvas.

Outline the Composition

Using a no.12 round, go over your outlines in Payne's Gray or Phthalo Blue.

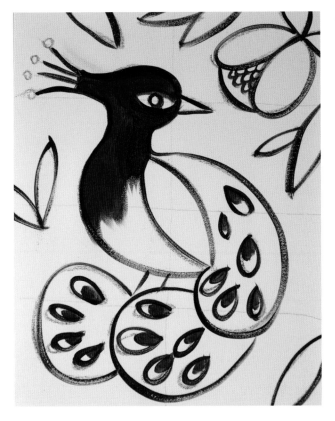

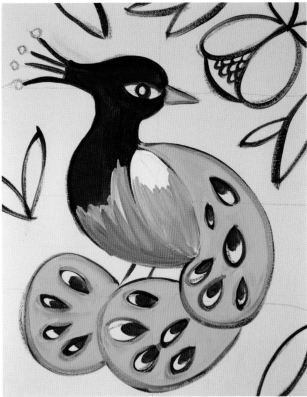

3

Paint the Head and Begin the Tail Tiers

With the same brush, mark an eye shape around the pupil and then fill in the head and neck with Phthalo Blue. While this paint is still wet, and without cleaning your brush, paint Phthalo Green underneath the eye and on the right side of the neck. This will recreate the shimmer of a peacock's feathers.

Add Ultramarine Blue teardrop shapes to the top of each dot in the tail tiers. Wash and dry your brush.

4

Paint the Center Wing, Belly and Beak

Sticking with the no.12 round, paint the whole center wing in Titanium White. While it is still wet, pick up some Pyrrole Red on your brush and paint the bottom half of the wing red. (It will blend and become reddish pink.) Add more red to your brush and paint the belly from the bottom. Then pick up some white to roughly join to the blue of the chest. Wash and dry your brush.

Next pick up some Hansa Yellow Opaque and paint into the center of the wing as pictured. Fill the tail tiers and beak with straight yellow.

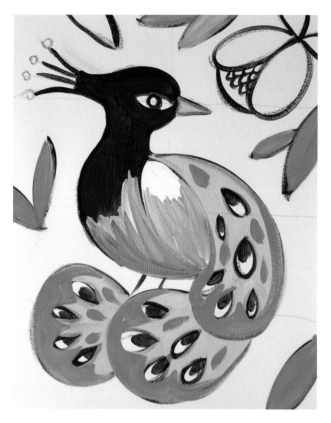

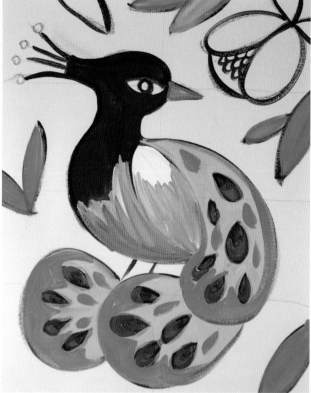

5

Build Up the Tail Tiers and Paint the Leaves

Continue using the no.12 round to add Teal to the bottom of each tail tier. Note that there is now no yellow between the teardrops on the tail and the edge of each tier because the yellow is still wet, the teal color will become a bright green.

Add some more yellow to your brush and fill in the leaves at the edge of the canvas. Wash and dry your brush.

6

Finish the Beak and Continue on the Tail Tiers

Use your clean, dry no.12 round to add some red to the wet yellow of the beak to make orange. Fill in the bottom of each teardrop spot on the tail with red also. Wash and dry your brush.

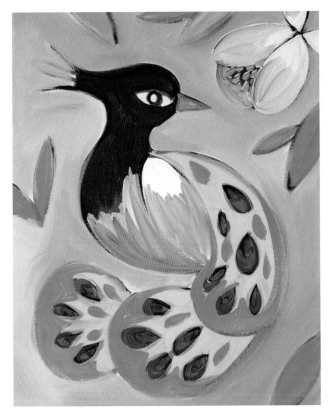

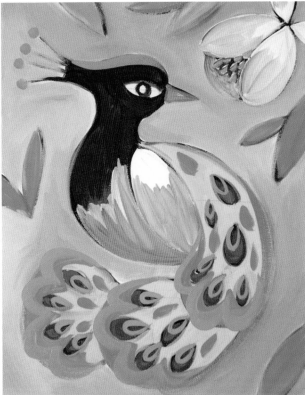

<div align="center">7</div>

Lay In the Background and Paint the Flower

Switch to a no.12 flat and mix Titanium White with a tiny amount of Carbon Black. Paint in the whole background and around the edges of the canvas. You may need to use a smaller brush in some places. (I like seeing the brushstrokes in this layer because they add movement.)

Switch back to the no.12 round and fill in the four petals of the flower with Titanium White. Without cleaning your brush, add Pyrrole Red to the petals from the top to the base, blending wet-into-wet. Wash and dry your brush.

Mix some Ultramarine Blue + Titanium White to make a mid blue for the center of the flower. (Note: You could really do this flower in any color or shape you want.) Wash and dry your brush again.

<div align="center">8</div>

Add Scalloped Edges to the Tail Tiers

Using the same brush, pick up some Teal and paint a scalloped edge on each of the three tail tiers. (At this point, there will still be some green between the Teal and the red of the teardrop shapes.)

Add a stripe of Teal on the top of the head and four fingerprint Teal circles at the end of the head feathers. Using the very tip of your brush and holding the handle at a 90-degree angle to the canvas (like a pencil), paint a Teal teardrop shape around the Ultramarine Blue part of each tail spot. Wash and dry your brush.

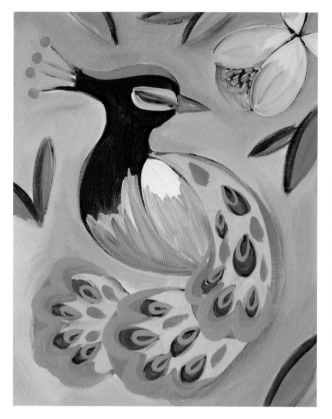

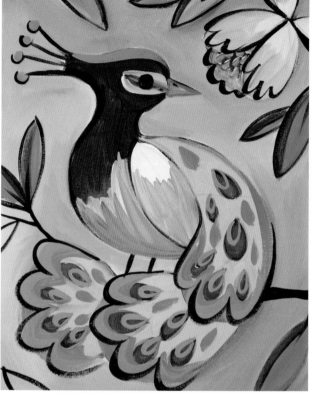

9

Begin Refining the Eye

With your clean, dry no.12 round, paint a Phthalo Green stripe diagonally through the eye and on one side of each leaf. Wash and dry your brush. Then, imagining that the eye is a rectangular shape with two rounded corners, swipe Titanium White across the top and bottom. This will pick up some green, and it will blend nicely. Wash and dry your brush.

10

Add a Branch and More Leaves, Continue Detailing the Feathers

Using the same brush and Carbon Black, paint in a branch from the right, about one quarter of the way up the canvas and continue it through to the left side of the tail feathers. (You can also add some more leaves at this stage if you like.) Then paint the two slightly angled legs (the feet are hidden), a scalloped line around the bottom of each tail tier, a black fingerprint circle for the eye, scalloped petals on the flower with a branch attached, outlines for all leaves with an indication of a center line on each leaf, lines to join the head feather dots to the head and some black shading on the left side of the neck. Wash and dry your brush really well.

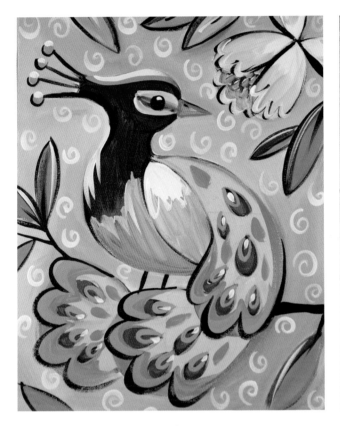

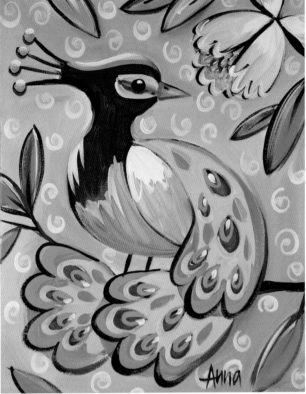

11

Finish the Feathers and Add Background Details

Continue with the no.12 round and add small white swirls all over the background, creating the impression of wallpaper. This extra detail breaks up the solid colors and makes the composition more interesting. Then add white dots to the head feathers and along the top of the head, a small curved highlight on the eye, small dots on every tail dot and a line on one side of each leaf and around the edges of the flower petals. Finally, paint a scalloped white line across the middle of the center wing. Wash and dry your brush.

12

Add Final Details to Finish

Using Iridescent Gold, add a fingerprint to every white background swirl and a gold curve under the red of every tail spot. Add small gold dots on the blue in the center of the flower.

Paint Hansa Yellow highlights to each leaf and dot on the head feathers, along the top of the head, on the beak and to both sides of the neck.

Using the no. 6 round, add a curve of red underneath the black eye circle and the head feather dots, as well as on the underside of each tail tier. Paint a line of red on the bottom of the beak and as a thin highlight on one side of each leaf and branch also. Sign your name—well done!

Visit artistsnetwork.com/paintingparty to download stencil templates and a bonus demonstration.

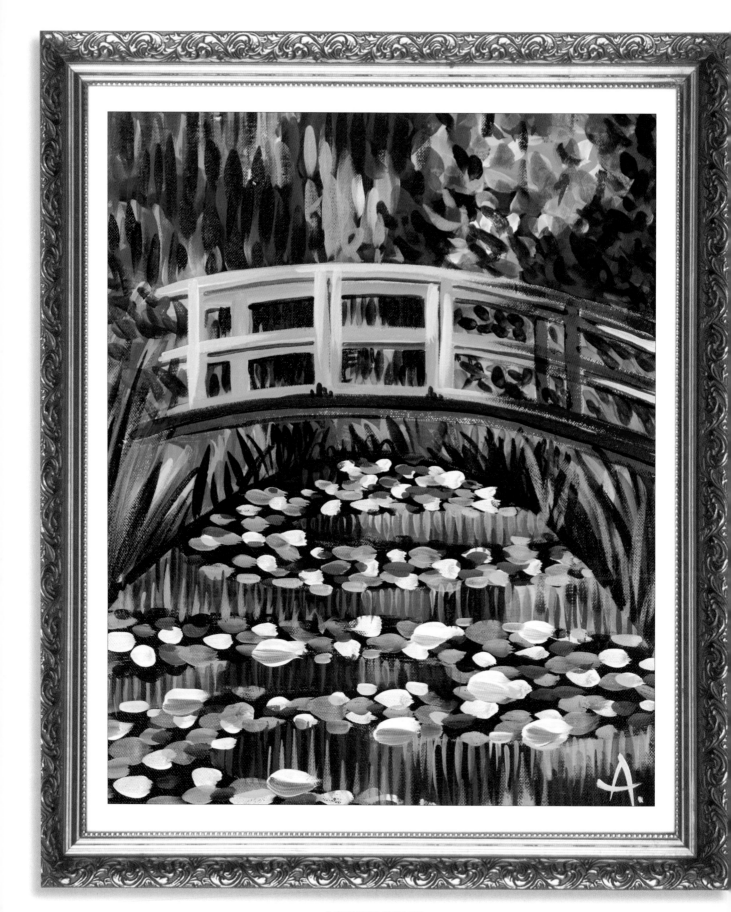

MONET'S BRIDGE

Acrylic on canvas
16" × 20" (40cm × 50cm)

MONET'S BRIDGE

Impressionism involves the use of primary colors and short brushstrokes to represent the appearance of reflected light. Claude Monet was one of the original Impressionists, and his water lily and garden paintings are legendary.

When I developed this paint-along project, I wanted to see if I could break down the Impressionist process so beginners could enjoy layering colors to create a painting that, when viewed from a distance, would surprise even themselves. I must have painted at least six versions of this painting before I decided on the method that achieved the best result. Since then, I've taught this in my studio many times, so my process has been refined even further.

I started with a photo of one of Monet's paintings and stretched it to fit my canvas. I then turned it into a black-and-white image so I could really see the areas of dark and light. I studied the painting, noting where the water's edge touched the grasses, that the flows of flowers on the surface of the water could be made with horizontal marks, and that the water itself was full of vertical lines (reflections). I noticed that the trees on the left were made of vertical lines and that the tree on the top right was more choppy. Finally, I looked at the perspective of the bridge. There is a front rail and a back rail; they come together in the center of the painting and split apart at the sides.

While there are a lot of steps to this painting, they are quite quick. If you take the time to really look at the examples and follow the instructions as best you can, you're bound to be rewarded with an artwork you'll barely believe you painted yourself!

MATERIALS

Surface
- ✿ stretched canvas, 16" × 20" (40cm × 50cm)

Golden Fluid Acrylics
- ✿ Dioxazine Purple
- ✿ Hansa Yellow
- ✿ Jenkins Green
- ✿ Pyrrole Red
- ✿ Sap Green
- ✿ Titanium White
- ✿ Ultramarine Blue

Jo Sonja's Acrylics
- ✿ Green Light/ Permanent Green

Brushes
- ✿ no. 12 flat
- ✿ nos. 6 and 12 rounds

Other
- ✿ chalk or charcoal
- ✿ palette
- ✿ paper towel
- ✿ water

STEP BACK!

When you spend a lot of time really close to a painting, you might find your inner voice criticizing your mark making. It's hard to be gentle on yourself after you've gone through so many stages to arrive at your end product. But it's important to remember that Impressionistic paintings are meant to be viewed at a distance. So before you put away your paints and brushes, prop your painting up on your easel (or a shelf or against a wall) and view it from several feet away.

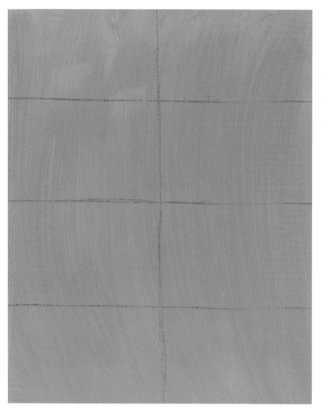

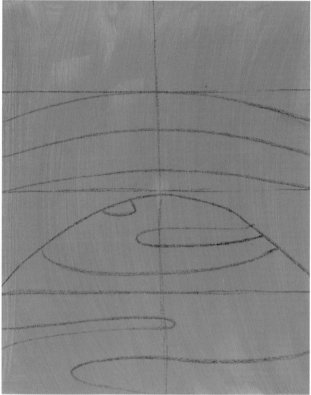

1

Prepare the Surface

Use a large brush to paint the entire canvas with bright green paint. I used Jo Sonja's Green Light/Permanent Green, but any similar green will work fine. Once dry, use chalk or charcoal to divide the canvas into eight rectangles as shown.

2

Begin Blocking In the Major Shapes

Block in the major shapes below the water's edge. Mark three gentle curves across the canvas in the quarter above the halfway line—this indicates the bridge. Add another curve in the quarter below the halfway line—this is your water's edge.

Mark outlines for the flows of flowers on the surface of the water. The top shape is like a bubbly C with a small chunk taken out of it at the top left. The bottom is like a back-to-front S in bubble writing.

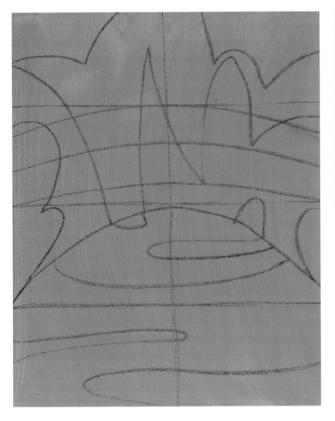

3

Finish Blocking In the Composition

Now it's time to lay in some shapes above the water's edge. Make a tall 3 shape filling the two middle quarters from left to right. Then add a range of flying-bird shapes as you move across the canvas. Include two upside-down U shapes on the right side of the water's edge.

4

Begin Filling In the Shapes with Color

Load your no.12 flat with Jenkins Green and fill in some of the shapes that you've just blocked in. Remember, there is no need to be too neat in these early stages because there are so many more layers to come. Wash and dry your brush.

5

Continue Building Up Color

Reload your brush with Hansa Yellow (or any bright yellow) and lay in six more areas of the canvas as shown. This color is very transparent, so the green of the undercoat will show through. This is a good thing!

Wash and dry your brush. Then using Sap Green, paint in all remaining areas except for the 3 shape on the far left side. Keep your marks loose. Edges do not have to be neat. Remember to paint the sides of your canvas as you go.

6

Fill In the C and S Curves

Load your clean, dry no.12 flat with Dioxazine Purple and fill in the C and reversed S shapes below the water's edge curve. This should not stand out as a purple color, however— it just needs to look really dark.

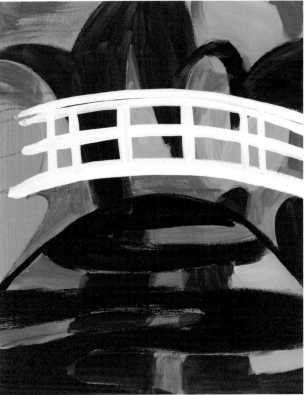

7

Begin the Bridge and Mark the Water's Edge

Switch to a no.12 round. Load it with Titanium White and paint the three bridge curves where you originally sketched them. Take a step back from your painting or look at it in a mirror to check that the curve is fairly even across the canvas. Wash and dry your brush.

Load your brush with Jenkins Green and paint the curved water's edge line below the bridge. Making this line darker will make it easier to remember that everything below this curve is either flows of flowers (horizontal marks) or surface reflections (vertical marks). Marks above the water's edge curve are grasses or leaves, so they will be angled to look natural.

8

Build Up the Bridge

Continue with a clean, dry no.12 round and use Titanium White to thicken the bottom two bridge lines. Then add a second railing across the top. Next add six uprights—two thin, then two thicker (these indicate two uprights that are almost behind one another) and two more thin. It's important to remember that these uprights are all vertical (parallel with the edge of your canvas). It won't look right if the lines are not totally vertical.

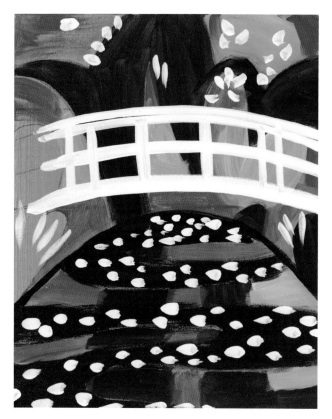

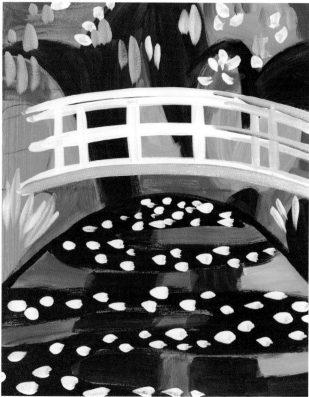

<div style="text-align:center">

9

</div>

Indicate Flowers and Grass Strands

Still with the Titanium White on your brush, add in some splotches to indicate flowers above the bridge, as well as a few grass strands below the bridge. Then paint some horizontal marks to symbolize flowers on the dark C and reversed S. If you are prone to neatness, jump about the canvas as you apply these marks. This will help them appear more random—you don't want them all in neat lines! The marks in the center of the canvas can be a bit smaller than the marks at the bottom edge, since those flowers are farther away from the viewer.

<div style="text-align:center">

10

</div>

Add Some Blue

Keeping the Titanium White on your brush, pick up a tiny bit of Ultramarine Blue and make marks in the trees above the bridge. When you get to the end, this light blue will look like the sky peeking through the leaves of the trees.

Add light blue on the lower half of the bottom bridge curve (closest to the center of the canvas) and on the right side of the center and top railings as indicated. Then add a few angled lines on the left side of the canvas, just below the bridge and above the water line. This will become part of a clump of grasses.

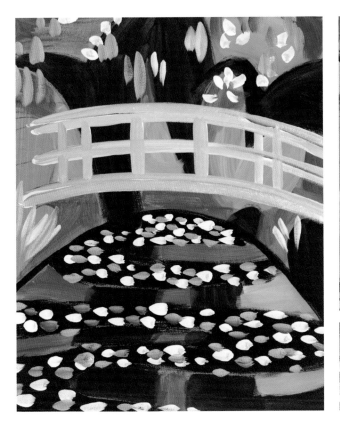

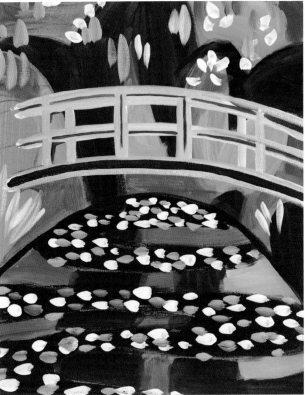

11

Indicate More Flowers and Continue Building Up the Bridge

Pick up a little bit more Ultramarine Blue with the same brush, and then add some blue flowers in among the white flowers in the C and reversed S. Once again, try to keep these marks random and keep them smaller in the center of the canvas. Wash and dry your brush.

Load your clean, dry brush with Titanium White once again, but this time pick up a tiny bit of Jenkins Green (to make a pastel green) and paint over the white of the bridge railings and uprights. Wash and dry your brush.

11

Refine the Bridge

Using Jenkins Green and the no.12 round, mark out the gaps between the top and center railings, as well as the uprights.

Finally, paint a dark green line just above the blue line on the bottom of the bridge. There should still be a little bit of pastel green showing above this dark green line, so if you've been too heavy-handed, paint that back in. Wash and dry your brush.

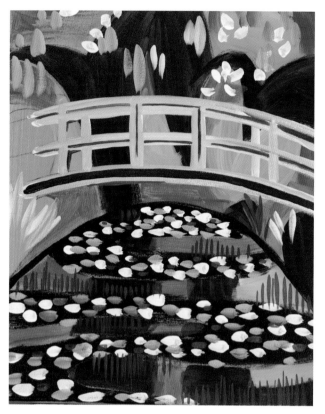

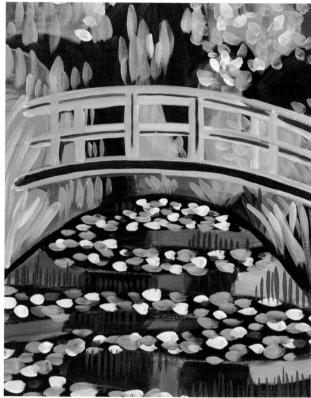

13

Continue Refining the Bridge and Add More Flowers

Still using your no.12 round, pick up some Pyrrole Red and paint some more flowers among the white and blue flower flows on the water. Add a very thin red line just underneath the bridge on the left side. (Red is the complementary color to green on the color wheel, so using red with green in this way will not only make the green pop, it will make your finished product look much more professional.) Wash and dry your brush.

Next load your no. 6 round with Pyrrole Red and paint some angled lines to symbolize grasses just above the waterline on the right side. Then using vertical strokes, paint in some red reflections across the surface of the water between the flower flows.

14

Add the Trees and Grass

Go back to your no.12 round and load it up with Hansa Yellow. Paint in some vertical lines for the willow tree on the top left and some more choppy lines for the foliage on the top right. Do angled "grassy" lines on top of the greens at the left and underneath the bridge. Then make some more yellow marks between the bridge railings.

Continue using Hansa Yellow and the no.12 round to add some horizontal marks for flowers in among the blue and white flower flows. These can overlap and touch a bit. Wash and dry your brush.

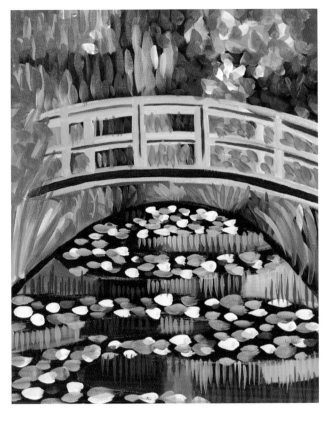

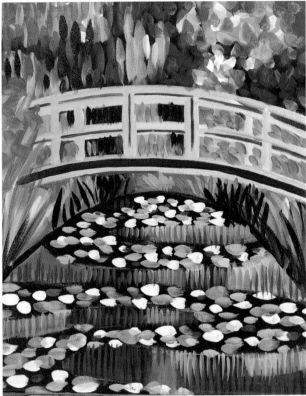

15

Continue Building and Blending the Trees and Grass

Using the tip of the same brush, paint in some very thin yellow strands between the red vertical lines on the surface of the water. Then reload the brush with Sap Green and paint in green vertical lines for the willow tree foliage at the top left and choppy marks for the tree at the top right. Then paint the grasses below the bridge (staying above the water's edge) and between the railings. Add some taller grasses at the left side of the bridge. This clump of tall grasses will now start to cover up the left side of the railings. By this stage, you really won't be able to see the edges of your first dark green shapes. If these edges are still noticeable, add more foliage marks until they don't stand out anymore. Wash and dry your brush.

16

Add More Grass and Flowers

Use your no. 6 round and Sap Green to add some more vertical lines through the middle of all of your water surface (i.e., not the C or reversed S). This will start to blend all of these lines together so they won't stand out as such a mix of colors.

Load your no.12 round with Dioxazine Purple and paint in more grass clumps above the water's edge on the left under the bridge. Then add a little bit of white to the purple that is still on your brush and add some mid-purple grasses on the right under the bridge. Also add some mid-purple vertical lines in the willow tree at the top left and between the center railings as shown.

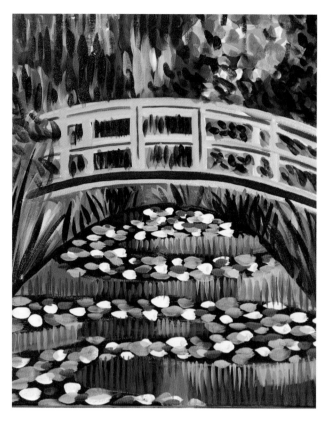

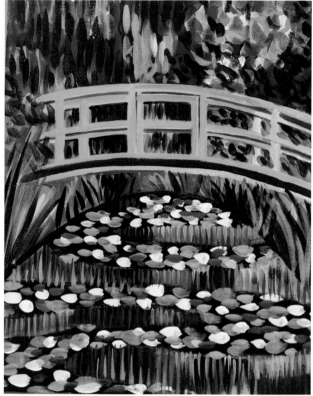

<div align="center">

17

</div>

Add Interest with Vertical Lines and Choppy Marks

With the mid-purple still on your brush, add some more flowers to the C and reversed S flows. Wash and dry your brush.

Load your no.12 round with Jenkins Green and work your way from left to right across the top of the canvas—vertical lines on the willow at the left and between the left and center uprights, and choppy marks on the top right and between the right-side uprights. Then add some dark green grasses under the bridge, once again working from left to the right. Wash and dry your brush.

<div align="center">

18

</div>

Add Highlights

Switch to a no. 6 round and add some thin vertical lines between the flower flows on the surface of the water with Jenkins Green. These lines must stay vertical—you don't want them to look like grasses. You should now have thick vertical reflection lines in a variety of colors all over the surface of the water between the flower flows.

Use a no.12 round to mix a small amount of Titanium White, Pyrrole Red and Hansa Yellow to create a pastel orange/apricot color for highlights. Paint some lines in the foliage in the center above the bridge, some grass clumps on the right side of the water's edge and some across the top and bottom of the reversed S.

Wash and dry your brush, then load it with pastel green (Titanium White + Jenkins Green) and repaint the railings and uprights on the bridge. Leave the blue on the right side alone. This will neaten up the edges of the bridge lines where your foliage marks might have gone over your railings.

With a no. 6 round and Pyrrole Red, paint about ten tiny lines in the foliage above the right side of the bridge. Adding this bit of red over the green really picks up the blue of the sky peeking through. Wash and dry your brush.

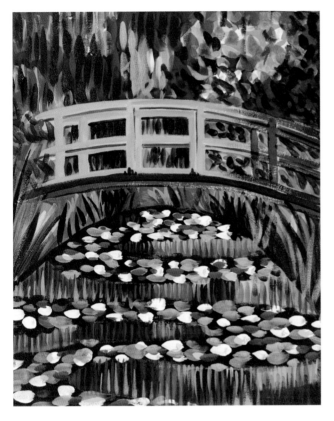

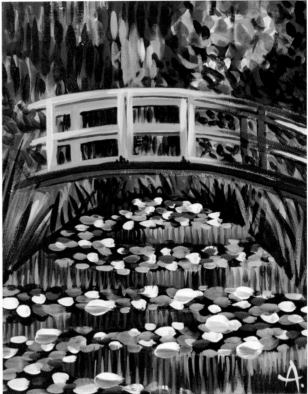

<div align="center">

19

Finish the Bridge

</div>

Load a no.12 round with Ultramarine Blue and paint blue lines over the railings and uprights on the right side of the bridge and on top of the light blue on the underside of the bridge curve. Use the very tip of your brush to add two little groups of tiny verticals at the bottom of the bridge just below the two uprights in the middle of the canvas. These two little areas break up the predictability of the bridge curve.

<div align="center">

20

Add Final Details to Finish

</div>

Use your no.12 round to paint some slightly larger feature flowers in the flows. There need be only about seven of these flowers, and they should be in the front part of the reversed S only. Make a slightly larger horizontal mark in Titanium White, then while it's still wet, add a line of Pyrrole Red to the underside of the seven flowers. Wash and dry your brush, then load it with a bit more Jenkins Green. Paint in some more grasses from left to right along and above the water's edge line.

Finally, use a no. 6 round and a mixture of Titanium White + Ultramarine Blue to add some small, mid-blue flowers just at the very edge of the flows. These will cover up any reflection lines that might have gone over the top of your flower marks.

Now sign your name! (Note that I used an "A" instead of my usual "Anna" on this one, since it is so obviously influenced by Monet's original.)

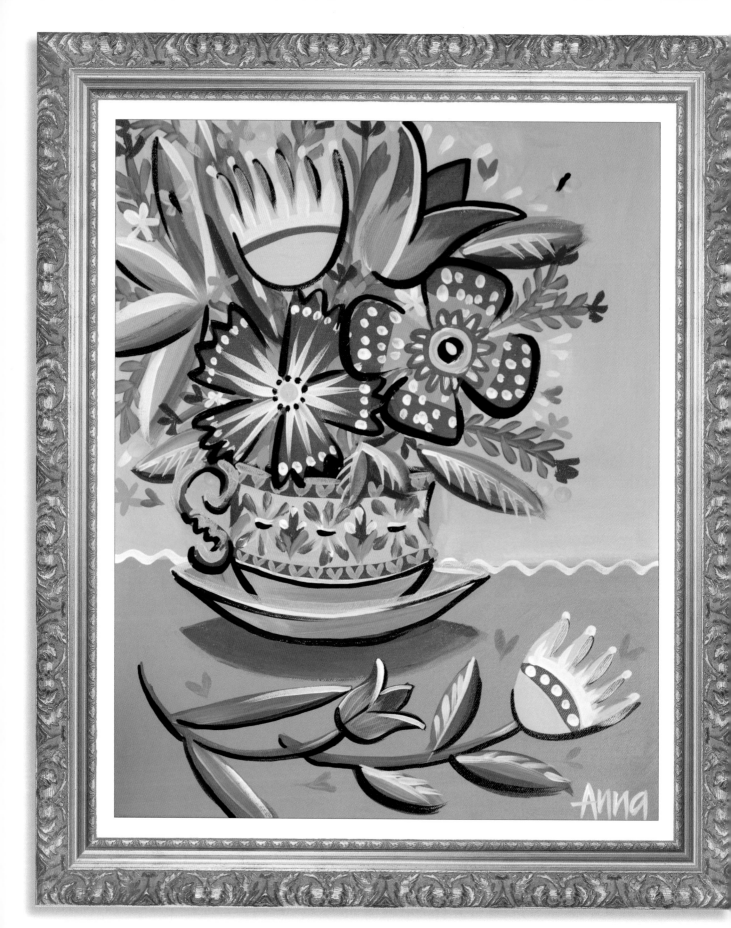

FOLK ART TEA CUP

Acrylic on canvas

16" × 20" (40cm × 50cm)

TEA CUP & BLOOMS

I really wanted to paint teacups with my beginners in the studio, but I was always concerned about achieving symmetry with the actual cup, so I put it in the too-hard category for some time. Then one day, suddenly, I knew how to teach it: Simply break down the shape of the cup into a series of easy shapes stacked on top of one another. A classic folk art pattern could disguise any little faults, and the big flowers would be the hero of the composition! I had to go to the studio and try it out straight away.

Since that day, there have been many wonderful versions of this painting created in my studio—every one similar, but different!

MATERIALS

Surface
- ✿ stretched canvas, 16" × 20" (40cm × 50cm)

Golden Fluid Acrylic Paints
- ✿ Dioxazine Purple
- ✿ Hansa Yellow Medium
- ✿ Iridescent Gold
- ✿ Pyrrole Red
- ✿ Sap Green
- ✿ Teal
- ✿ Titanium White
- ✿ Ultramarine Blue

Brushes
- ✿ no. 12 flat
- ✿ nos. 6 and 12 rounds

Other
- ✿ chalk or charcoal
- ✿ palette
- ✿ paper towel
- ✿ water

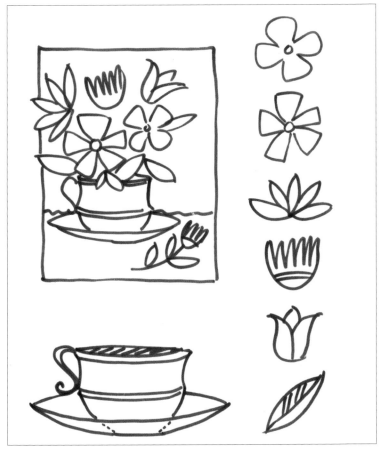

TEA CUP & BLOOMS SKETCHES

61

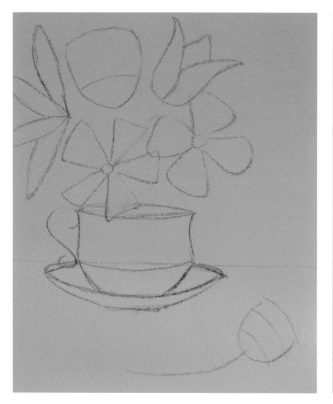

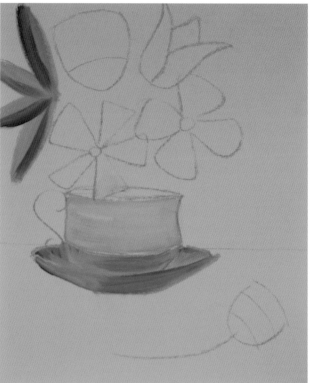

Prepare the Surface and Sketch the Composition

Start by undercoating the entire canvas with Hansa Yellow Medium. Let it dry. Sketch your composition with chalk or charcoal. Start with a horizontal line about one-third up from the bottom of the canvas. Then draw the main body of the cup—a curved rectangle—just above that line. Continue sketching the rest of the cup and saucer (a leaf shape), the five flower shapes and the flower lying on the table. Make sure you fill up the whole canvas (i.e., the flowers should touch the top edge of the canvas, and the feature flower on the table should not be too small).

Paint the Cup and Saucer

Load your no.12 round with Titanium White, then add a little bit of Ultramarine Blue. Blending on the canvas (not the palette), lay in color on the cup and saucer (the saucer should be a bit deeper in tone), as well as the flower on the left side. Wash and dry your brush.

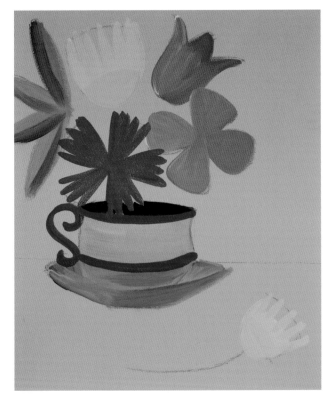

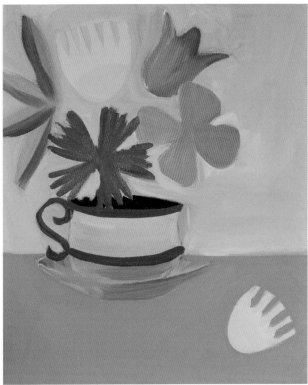

Begin the Flowers

Load the same brush with Pyrrole Red and paint the handle, the rim and the curve across the middle of the cup. Build up the "spray" flower just above the rim by painting lines from the outside of the flower into the middle with four or five lines forming each petal. Then add some Titanium White to your brush. Make sure you pick it up from the edge of your puddle of white paint so as to keep the rest clean. Paint in the tulip and two bottom flowers. These flowers should fill up at least two-thirds of the canvas. If they're smaller than you intended, just add some more flowers to your composition. Wash and dry your brush.

Still using the no.12 round, pick up some Titanium White and a little bit of Hansa Yellow and paint in the heads of the top center flower and the table flower. Wash and dry your brush.

Lay In the Background

Switch to your no.12 flat and paint the lower third of your canvas (the tabletop) Teal. Then add Titanium White to the mix and paint the rest of your canvas (the wall behind). It's fine to leave some of the original yellow background showing through. Yellow is a magic, zinger color, and if you don't leave a little showing through at this stage, you might find that adding a little extra at the end will enhance your painting.

Visit artistsnetwork.com/paintingparty to download stencil templates and a bonus demonstration.

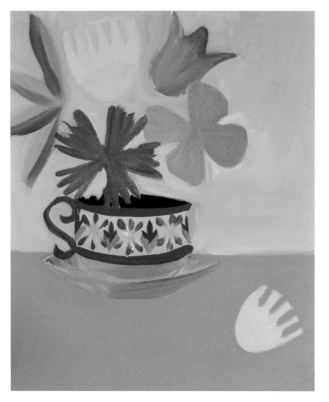

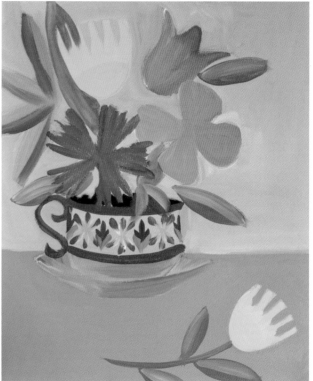

5

Begin the Folk Art Pattern

Switch back to the no.12 round to begin building up your folk art pattern. Start with the yellow petals, three lines down (from the outside in) and three lines up. While the yellow is still wet, add some red to the tips of the petals. Then use Sap Green to paint a V between each yellow flower with three red lines "growing" into it. Make sure the background has dried thoroughly before you move on to the next step.

6

Paint the Leaves and Stem

Add four or five leaves using Sap Green and your no.12 round. Four or five is plenty—you don't need to fill up the whole space. While those leaves are still wet and without washing out your brush, pick up some Hansa Yellow and paint wet-into-wet over half of every leaf as shown.

Use the same brush and same green/yellow mixture to add a curved stem and three leaves to the table flower. Paint half of each leaf yellow.

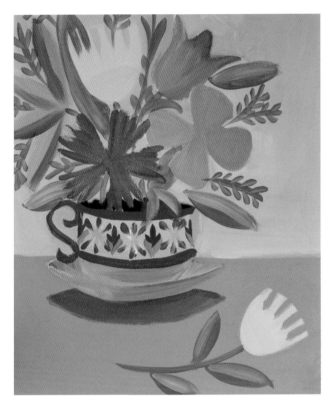

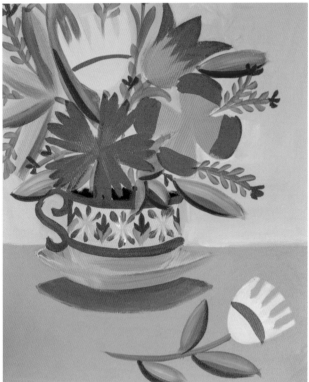

7
Continue Adding Leaves

Load your no.12 round with a little more green and paint approximately nine sprays of fern-like leaves between the flower heads, springing from the center of the bouquet out. Add stems at the base of each flower (going into the cup) wherever you can. This will start to thicken out the bunch of flowers quite nicely.

Wash and dry your brush, then pick up some Titanium White + Ultramarine Blue to mix a mid-blue color. Paint a leaf shape underneath the saucer to indicate a shadow. (Try to get your shadow shape as close as possible to the one shown above.)

8
Continue with the Flowers

Use Pyrrole Red and a clean, dry no.12 round to paint three little petal shapes at the top of each fern spray. Then add a thin red line on the underside of each leaf, including the table flower leaves. Next paint a curved red line across the two yellow flowers and lay in more red on the tips of the tulip and on the outside of the four-petal flower. Wash and dry your brush.

Visit artistsnetwork.com/paintingparty to download stencil templates and a bonus demonstration.

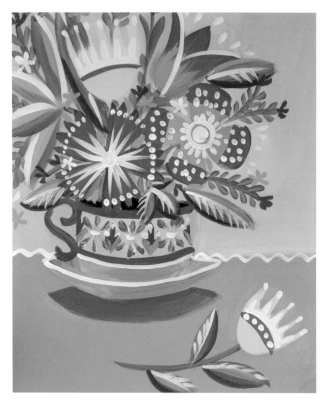

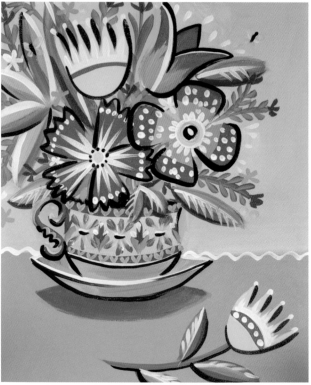

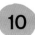

9

Refine the Flowers and Saucer

Load up your no. 6 round with Titanium White and paint a white centerline and ribs on one half of each leaf and white lines on the upper side of each of the blue petals. For the bottom-left red flower, paint a white center with lines radiating outward toward rows of dots. Add white circles and dots on the four-petal flower, white dots and lines on the two yellow flowers and two white lines on the tulip. Then paint three little white flowers in among the bouquet and some Tic-Tac-sized marks on the wall near the tulip and four-petal flower.

Use the same brush and Titanium White to paint a line on the edge of the saucer, a white line below the red line in the middle of the cup and white tips and centers in the folk art pattern. Then add a wavy line across the canvas where the table meets the wall.

Wash and dry your brush, then load it with Teal and add about six little flowers to the bouquet in between the larger flowers and leaves. This will hold the bouquet together nicely and keep the flowers from looking like they're floating.

10

Finish the Folk Art Pattern and Outline the Shapes

Still using your no. 6 round, load up some Hansa Yellow and paint V-shaped hearts on the cup handle, across the red lines on the cup and in the centers of the two red flowers. Add two little yellow butterfly shapes in among the flowers as well. Then dip your fingertip in Hansa Yellow and add about seven yellow dots close to the arrangement.

Wash and dry your brush, then load it with Dioxazine Purple and loosely outline the flowers, the cup (including the pattern and handle) and the table flower. These lines should be broken, and not everything should be outlined. It's best to do a little bit and then stand back and take a look, then do a little bit more. This way you won't go overboard.

Add a bit of dark purple detail to the centers of your red flowers. If you like, you can also add tiny purple butterfly bodies at this stage.

Receive bonus materials when you sign up for our free newsletter at artistsnetwork.com.

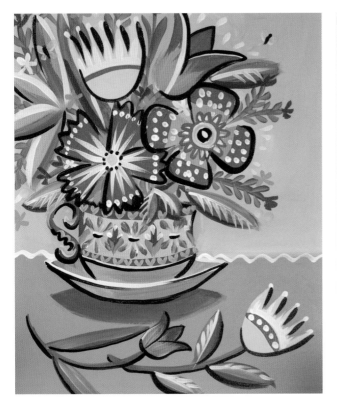

11

Add Another Flower (Optional)

If you have plenty of the table still showing, you might want to add another flower to balance out the composition. However, if your cup is closer to the bottom of the canvas, you may not need to do this. It's up to you.

12

Add Final Details to Finish

Use your no. 6 round and a mix of Titanium White + Ultramarine Blue to add some V-shaped hearts around the bouquet and the table flowers. Make them the same shape that you used on the edge of the cup.

Wash and dry your brush, then load it with Titanium White and add highlights to the second table flower (if you have one).

Wash and dry your brush again, then reload with Iridescent Gold. Add a line of Iridescent Gold to the edge of the saucer, to the cup and handle and on the petals of the yellow flowers. If you like, add some more Tic-Tac marks spraying out above the yellow flower at the top of the canvas. Now sign your name— you're done!

Visit artistsnetwork.com/paintingparty to download stencil templates and a bonus demonstration.

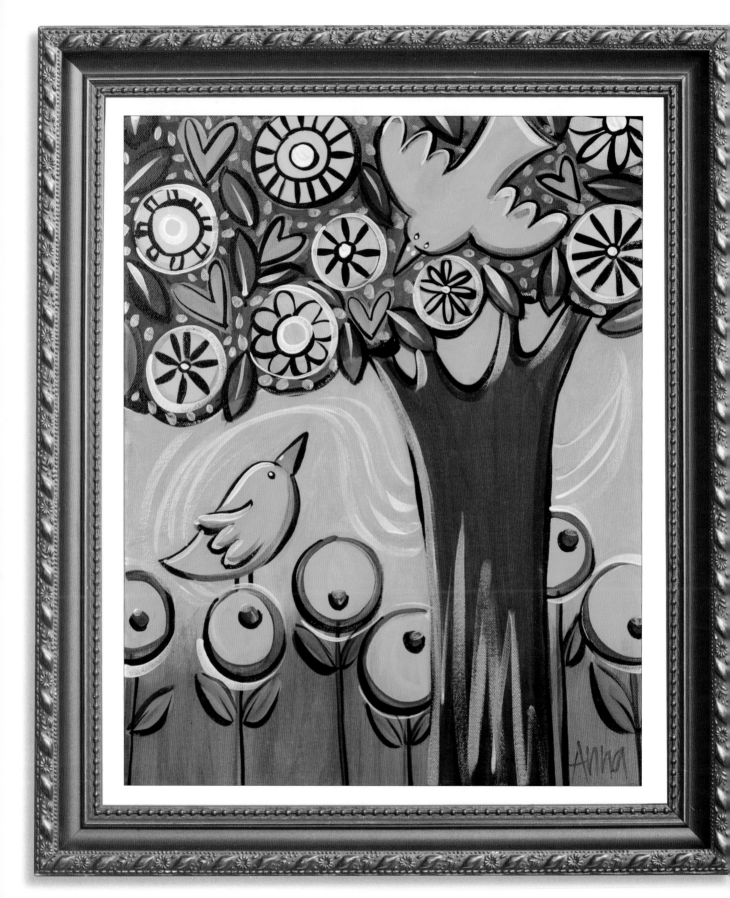

LOVE BIRD TREE

Acrylic on canvas

16" × 20" (40cm × 50cm)

LOVE BiRD TREE

This project was originally designed to work on two canvases, side by side. I wanted to do a parent-child paint-along in the studio, so I decided one bird could be on one canvas and the other bird on the canvas next to it. The canopy of the tree would go across both canvases, as would the circular flowers at the bottom. The patterns, flowers and hearts in the canopy could be symbolic, indicating the number of boys and girls in the family or matching a particular decor.

Delightfully, one lady came to the paint-along with laser-copied cutout faces of every person in her family. She then collaged each of them onto the centers of each flower and added two birds to the tree, symbolizing herself and her husband. One of her daughters had died, so was included with the ground flowers. It was a deeply personal painting that she had wanted to do for some time, and I was so happy she felt comfortable and could do her thing during the paint-along.

The composition is designed to be a mix of large, open areas and heavily patterned areas and can be painted in a vertical or horizontal format. The tree canopy can be Ultramarine Blue or Carbon Black, and the sky can be Diarylide Yellow or a mix of Ultramarine Blue and Titanium White. Experiment with some different colors to make it your own!

MATERIALS

Surface
- ✿ stretched canvas, 16" × 20" (40cm × 50cm)

Golden Fluid Acrylic Paints
- ✿ Carbon Black
- ✿ Diarylide Yellow
- ✿ Hansa Yellow Medium
- ✿ Iridescent Gold
- ✿ Phthalo Green (Blue Shade)
- ✿ Quinacridone Magenta
- ✿ Raw Sienna
- ✿ Ultramarine Blue
- ✿ Zinc White

Brushes
- ✿ no. 12 flat
- ✿ nos. 6 and 12 rounds

Other
- ✿ chalk or charcoal
- ✿ palette
- ✿ paper towel
- ✿ water
- ✿ white gesso

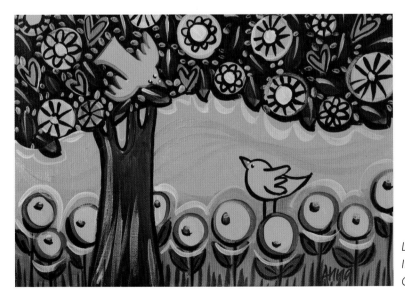

LOVE BIRD TREE IN LANDSCAPE ORIENTATION

Prepare the Surface and Sketch the Composition

Undercoat your canvas with white gesso. Using either charcoal or chalk, mark the outlines of the composition as indicated. Start with the trunk sides, then add three U shapes to make branches. Add as many circles and hearts as you want (perhaps use a heart for every member of your family), then add the circles across the bottom and the two birds.

Begin the Canopy

With your no.12 round, color the canopy of the tree with Ultramarine Blue (or Carbon Black if you'd like to do something a little different). Don't worry about being too neat at this early stage. Wash and dry your brush.

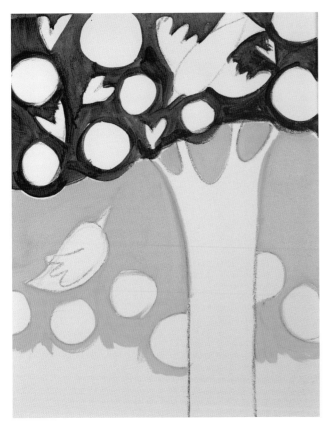

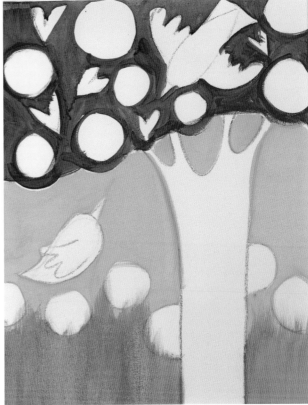

<div align="center">

3

Lay In the Sky

</div>

With the same brush, fill in the sky with Diarylide Yellow. This color finishes just below the circular flowers across the bottom of the canvas.

<div align="center">

4

Lay In the Foreground

</div>

While the yellow is still wet and without washing out your brush, mark on some vertical strokes, from the lower edge of the canvas up, in Quinacridone Magenta. Because you still have some yellow on your brush, this will appear a dark orange. Wash and dry your brush.

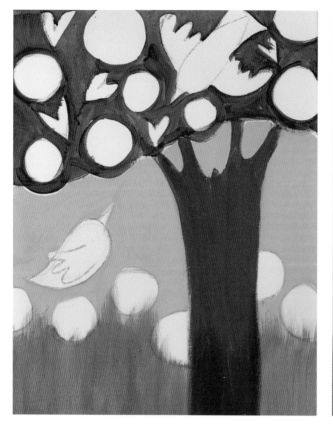

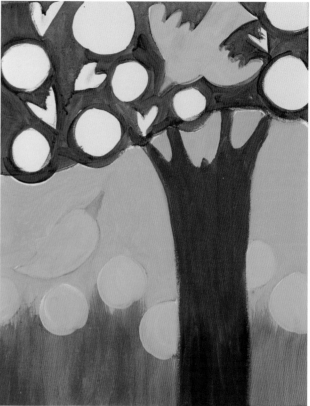

5

Paint the Tree Trunk

Using Raw Sienna, paint the tree trunk with the no.12 round. Without washing out your brush, pick up some Phthalo Green (Blue Shade) and paint some vertical lines, wet-into-wet, from the bottom of the trunk upward. This will create a really dark base for your tree. Wash and dry your brush really well.

6

Paint the Birds and Flowers

Load your no.12 brush with Hansa Yellow Medium and paint in both birds, including the beaks. Then, without washing out your brush, add a teeny bit of Quinacridone Magenta to the tip and paint the beaks, wet-into-wet, so they become orange. Then go back and load up with more yellow, and paint the circular flowers along the bottom of the composition. Wash and dry your brush.

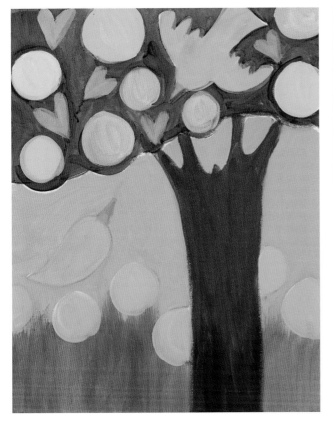

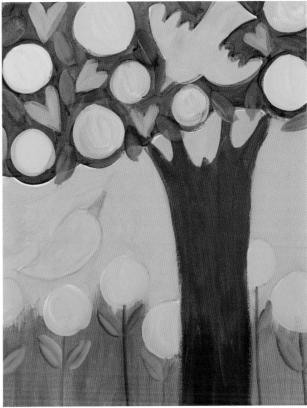

7

Paint the Circles and Hearts

Paint the circles and hearts in the sky with any combination of three pastel colors. Here I used Ultramarine Blue + Titanium White, Pyrrole Red + Titanium White and Hansa Yellow + Titanium White. I made all of my hearts pink, but it really is up to you. Wash and dry your brush between colors.

8

Paint the Leaves

Load your no.12 round with Phthalo Green and Hansa Yellow (both colors on the bristles of one brush). Fill in the gaps between the circles and hearts in the tree canopy with leaf shapes. Make sure you include leaves at the lower edge, overlapping the blue and yellow background line. With the tip of your brush, add stems to each of your yellow circle flowers and at least two leaves on each stem. Pick up some more yellow on your brush in order to get a lovely blend of yellow and green in these leaf shapes. Wash and dry your brush.

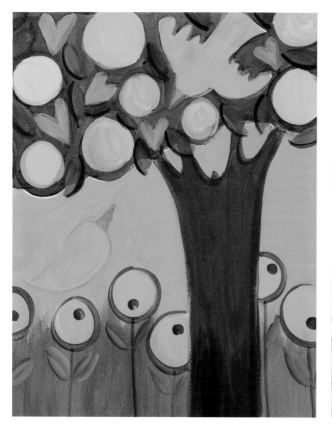

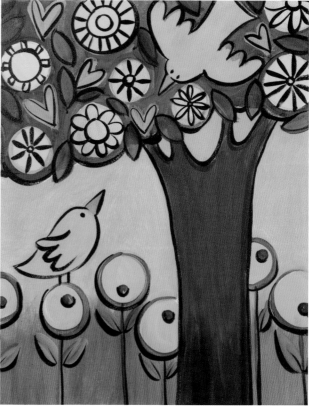

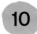

9

Detail the Flowers and Leaves

Using Quinacridone Magenta, outline the circular flowers and add a fingerprinted dot for the center—but make them off center (so they don't look like bosoms!). Then, using the tip of your brush, mark a Quinacridone Magenta line on the low side of each of your green tree leaves and on the right side of your trunk and branches.

10

Layer the Background and Detail the Birds and Canopy

Your background will now be well and truly dry. Load your no.12 flat with a very small amount of Zinc White, and with a circular motion, paint over the yellow of your background. This technique will make the background look a little cloudy and more interesting. Wash and dry that brush.

Load your no. 6 round with Carbon Black and paint a variety of flower designs in the circles in the tree canopy. Then with the black still on your brush, outline the hearts, top sides of the tree leaves, birds, circular flowers, centers and stems, tree trunk and branches. When adding lines to your birds, note the birds' eyes are very close to the beak and not farther up the head. The wings are like three-fingered hands. If you need another coat of yellow on either of your birds, go ahead and do that. Wash and dry your brush.

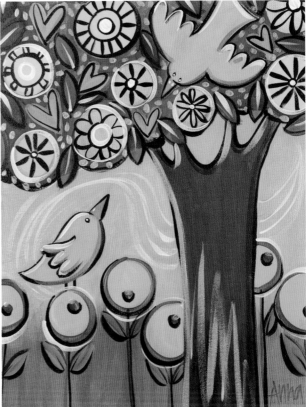

11

Indicate a Breeze and Add Highlights

Using your no.12 round, add some Titanium White curved lines in the sky to indicate a breeze. (This would work equally well if painted in gold.) With the white still on your brush, add some white highlights to each of your treetop flowers, a thin white line as a center spine in each of the green leaves, tiny white nostrils on both beaks, tiny dot highlights in each bird eye, highlights (on the high side) on your birds and loose curves around the circular flowers. Wash and dry your brush.

12

Add Final Details to Finish

Now load your no.12 round with Iridescent Gold and highlight lines on the left side of the trunk and branches, as well as a zigzag at the bottom of the trunk. Add small gold dots to pattern the blue of the tree canopy using either your no. 6 round or your smallest fingertip. Build up the pattern in the canopy to make it totally different from the expanse of flatter color in the sky. You're all finished—now sign your name!

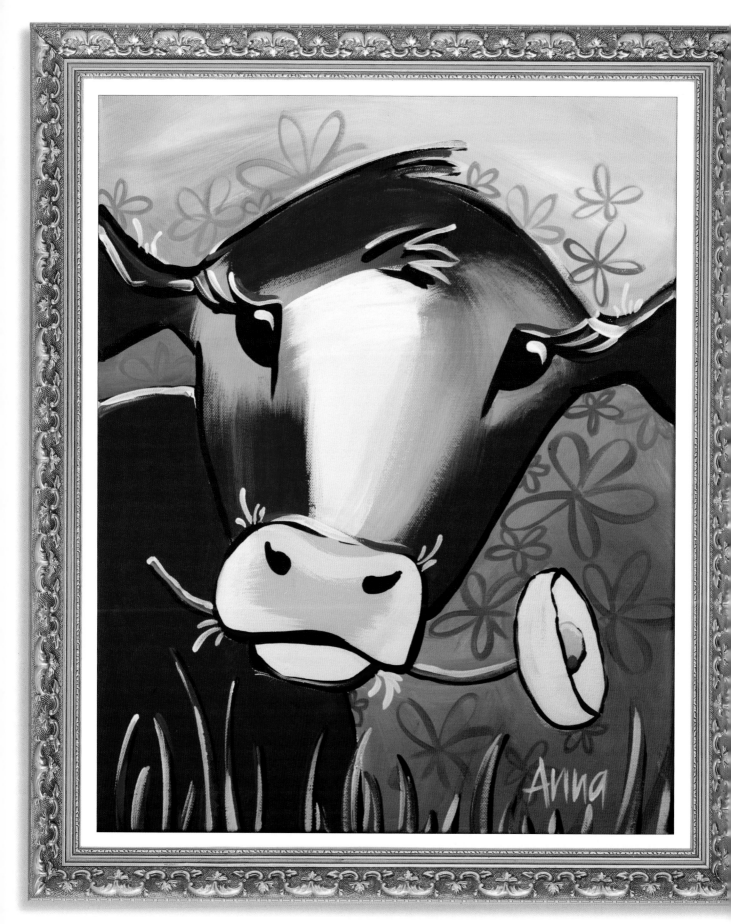

CHEEKY COW

Acrylic on canvas

16" × 20" (40cm × 50cm)

COW

I live in Queensland, Australia, where a lot of people are connected to farming in some way. So this Cheeky Cow project has been a big hit locally!

This cow can be painted in more classic colors (browns, yellows, reds), or you can try using crazy fluorescent colors if you like. If you do choose to go for "crazy," just make sure you paint a white band down the front of the cow's head like the traditional cow has in the painting on the previous page. This will help to create a tonal difference.

Because of the expanse of flat color for the body and the rest of the face, I added some line-drawn flowers to the background and some grasses to the foreground. You can make these elements more detailed if you wish.

The flower in her mouth can also be changed to become a more obvious daisy shape or any other flower you wish—even a bunch of flowers would look great!

The sky color could also be changed if you like—perhaps try Magenta!

MATERIALS

Surface
- ❀ stretched canvas, 16" × 20" (40cm × 50cm)

Golden Fluid Acrylic Paints
- ❀ Burnt Sienna
- ❀ Diarylide Yellow (or Arylamide Yellow)
- ❀ Dioxazine Purple
- ❀ Hansa Yellow Medium
- ❀ Green Gold (or Sap Green)
- ❀ Pyrrole Red
- ❀ Titanium White
- ❀ Ultramarine Blue

Brushes
- ❀ no. 12 flat
- ❀ nos. 6 and 12 rounds

Other
- ❀ chalk or charcoal
- ❀ palette
- ❀ paper towel
- ❀ water

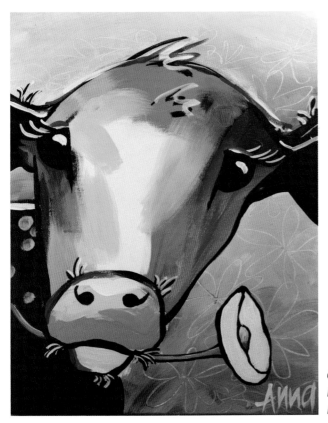

CHEEKY COW IN "CRAZY" PALETTE

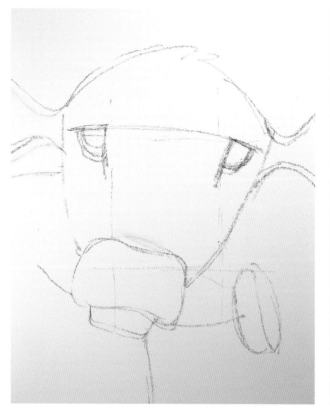

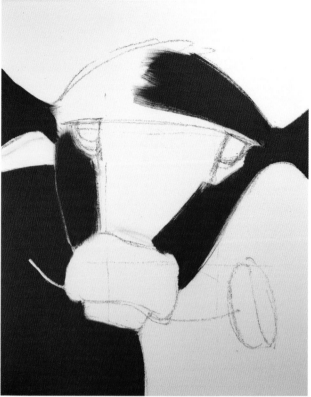

<div align="center">

1

Sketch the Composition

</div>

Using chalk or charcoal (I have charcoal so the lines are easier for you to see), divide your canvas into approximate thirds, vertically and horizontally. Paint the squished rectangle shape of the snout on the bottom left intersection and the eye shape in the top left intersection. Then fill in the other lines for the second eye, the arched top of the head, the ears that are thin then thick, the slightly rounded cheeks, the back and chest lines, the U-shaped bottom lip and the curves of the flower. Do this upside down if you like. (I often find it's easier to copy shapes this way.)

<div align="center">

2

Lay In Some Brown

</div>

Using your no.12 flat, load up with Burnt Sienna and fill in the areas as indicated. Wash and dry your brush.

Receive bonus materials when you sign up for our free newsletter at artistsnetwork.com.

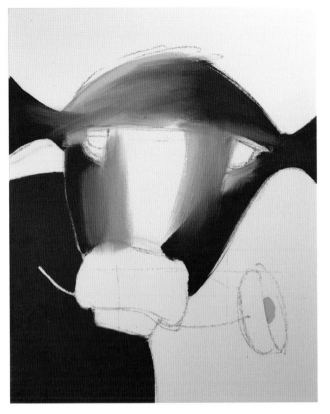

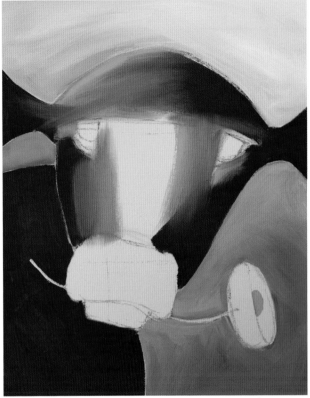

3

Build Up the Head and Begin the Flower

While the Burnt Sienna is still wet on the canvas, load the same brush with Diarylide Yellow. Paint the cow's head as indicated, then fill in the center of the flower. Wash and dry your brush.

4

Lay In the Background

Reload the same brush with some Titanium White and Ultramarine Blue to fill in the background, adding more white at the top. Remember to paint the sides and really get your paint into the folded corners of your canvas. It's OK to show the brushstrokes! Wash and dry your brush.

Visit artistsnetwork.com/paintingparty to download stencil templates and a bonus demonstration.

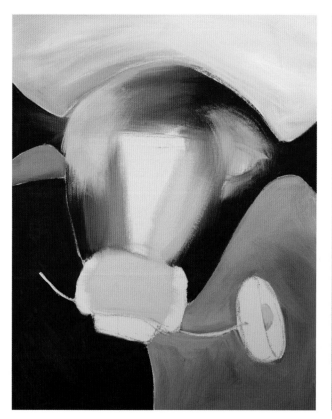

5

Lay In Some Yellow

Still using the no.12 flat, load up with Hansa Yellow Medium and add yellow areas on the eyes, the right side of the white middle, the center of the snout and the high side of the flower center. Wash and dry your brush.

6

Lay In Some White

Make sure your cow's face is thoroughly dry. (Use a hair dryer if needed.) Then using the no.12 flat, add Titanium White to the center of the face, around the snout and as the petals of the flower. Wash and dry your brush.

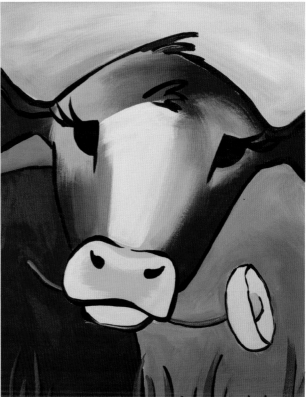

7

Paint the Flower Stem and Grass

Switch to a no.12 round and load up with either Green Gold or Sap Green. Paint the flower stem and grasses at the bottom of the canvas. Make the grasses slightly curved and allow some to overlap. Wash and dry your brush.

8

Detail the Face and Flower

Reload your no.12 round with Dioxazine Purple. You're going to use this as a dark rather than an obvious purple, so make sure you have enough paint on the brush. Using the tip of the bristles, start at the top of the head and paint the ears, the face shape, the eyes, the tuft on the forehead, the snout and mouth, the flower and a shadow line on the right side of your grasses. Let it dry before moving on to the next step.

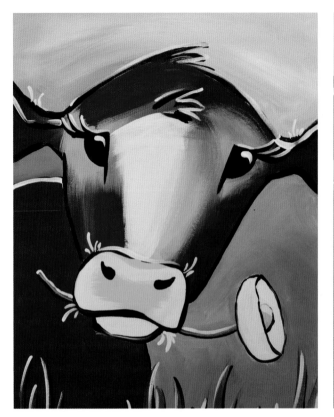

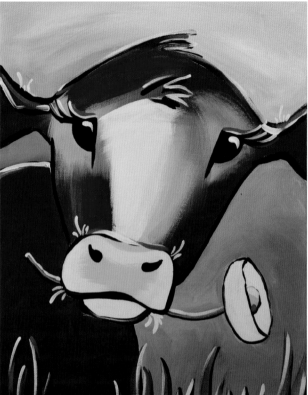

<div align="center">

9

Add Highlights

</div>

Load your no. 6 round with Titanium White and paint an apostrophe-shaped highlight on each eye. Then, working from the top of the painting down, add highlights to the top of the head, the tuft, the eyelashes, the top of the back, the snout, the flower stem and the grasses. Add three or four little white hairs on each ear and in four places around the snout. Add a white highlight to the center of the flower. Wash and dry your brush.

<div align="center">

10

Add Red Accents

</div>

Reload the no. 6 round with Pyrrole Red and add suggestions of color across each ear and the top of the head, above the back and each eye, along the top of the snout and the bottom of the flower center and on the right side of the grasses.

Receive bonus materials when you sign up for our free newsletter at artistsnetwork.com.

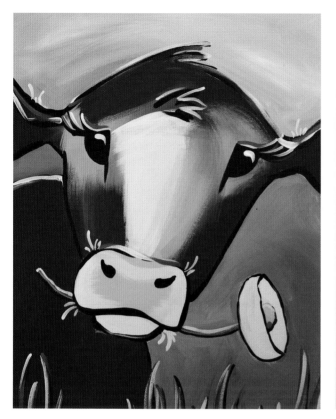

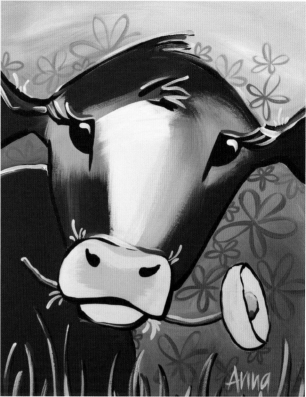

| 11 | 12 |

Detail the Grass and Flower Center

With a clean, dry no. 6 round, add some Hansa Yellow to the left side of the grasses and in the middle of the flower center. Wash and dry your brush.

Finish the Background and Add Final Details

Load up the no. 6 round with a mixture of Titanium White + Ultramarine Blue. Paint flower shapes into the blue background. These can be whatever size you wish. I used both small and large shapes. I also decided to add some more grasses below the snout at this stage. You could even add some dragonflies or butterflies in among the grasses if you wish. When you're happy with it, sign your name.

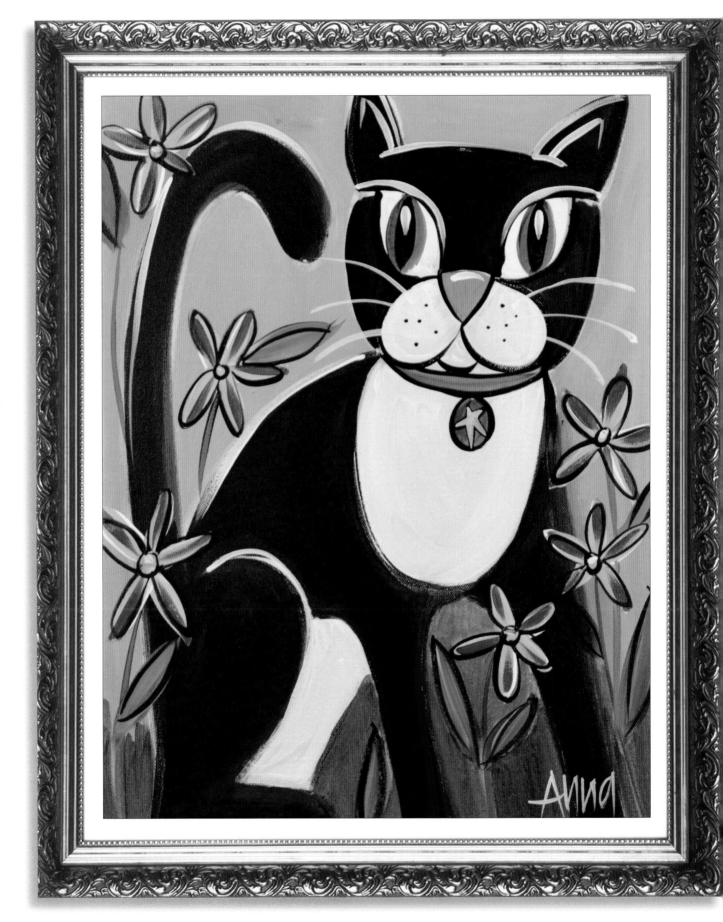

FELIX CAT

Acrylic on canvas

16" × 20" (40cm × 50cm)

CAT

Many years ago, we decided my stepdaughter needed a pet. I'm actually allergic to cats, but we lived in a townhouse where dogs weren't allowed, and my stepdaughter had her heart set on getting a furry friend. So her father took her to the RSPCA, and they came home with a beautiful ginger cat she promptly named Coco.

I learned to draw cats by watching Coco. And I painted and sold many framed gouache paintings of him in all his superiority—lounging on the cushions, peeking around the curtains, curled up on the lawn. Coco died in 1993, but I like to think he lives on a little every time I paint a cat, because it all started with him.

There are so many color options for your own version of this cat painting. Try my colors first to build your confidence, then try again with some colors of your own. Changing the width of the neck and collar will also change the personality of your cat dramatically. Feel free to experiment and see what you prefer.

MATERIALS

Surface
- ✿ stretched canvas, 16" × 20" (40cm × 50cm)

Golden Fluid Acrylic Paints
- ✿ Carbon Black
- ✿ Dioxazine Purple
- ✿ Hansa Yellow Medium
- ✿ Phthalo Green (Blue Shade)
- ✿ Quinacridone Magenta
- ✿ Titanium White
- ✿ Ultramarine Blue

Brushes
- ✿ no. 12 flat
- ✿ nos. 6 and 12 rounds

Other
- ✿ palette
- ✿ paper towel
- ✿ water

CAT IN
ALTERNATE
PALETTE

85

<div align="center">

1

Prepare the Surface and Outline the Composition

</div>

Use a no.12 flat to undercoat your whole canvas with Hansa Yellow Medium.

Load your no.12 round with Titanium White and paint the outline of the cat. Start with the curved triangle of his nose. Then paint the leaf shapes of his eyes, starting from the corners of the nose and flattening out at the top. Next come the two U shapes of his face next to the nose, the little curve of his mouth and the big U of the bib on his chest.

Finish outlining the shapes with ears that touch the top of the canvas, an upside-down U between the front legs, a number 2 shape that is the knee and foot of the back leg, and the curve of the tail that fills the top corner space.

<div align="center">

2

Paint the Face, Bib and Belly, and Lay In the Background

</div>

With the white still on your brush, paint in the eyes, face, bib and tummy. Wash and dry your brush.

Switch to a no.12 flat and load up with Titanium White and a small amount of Ultramarine Blue. Then, blending on the canvas, not on the palette, loosely fill in your background. You can make it a bit darker at the bottom of the canvas if you like— just add a bit more blue. Wash and dry your brush.

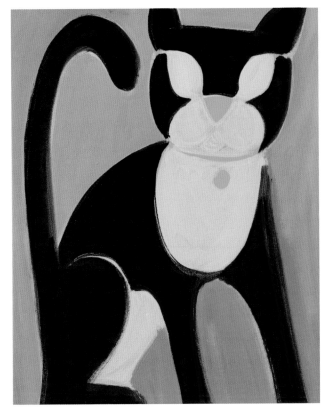

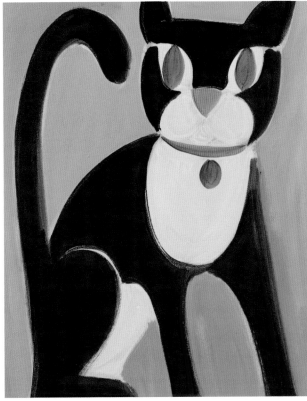

Lay In the Dark Color

Using Dioxazine Purple and your no.12 flat, fill in the tail, body, legs and head. Only the nose, collar and tag are still yellow now. Painting purple over the yellow should result in a color that's very dark—almost black. That's exactly what you want! Wash and dry your brush.

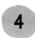

Paint the Eyes, Nose and Collar

Switch to your no.12 round. Load it with Titanium White and a small amount of Quinacridone Magenta, then paint the nose and collar. Wash and dry your brush. Then load up with Phthalo Green and paint the leaf shapes of the eyes and the round tag. The eyes should be vertical and parallel to each other. Be careful not to angle them—they just won't look right. Wash and dry your brush.

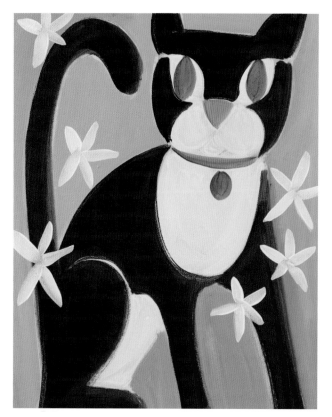

5

Add Flowers

With a clean, dry no.12 round and Titanium White, paint approximately six large flower heads as indicated. Wash and dry your brush.

6

Paint the Flower Stems and Leaves

Using the same brush, load up with more Phthalo Green and paint curved stems and leaves for each flower head.

Without washing out your brush, pick up some Hansa Yellow from the side of a puddle of yellow on your palette and paint wet-into-wet on each of the leaves. This will make the leaves look a lot more painterly than if you left them as a flat green. Wash and dry your brush.

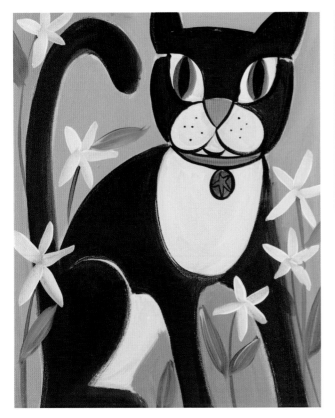

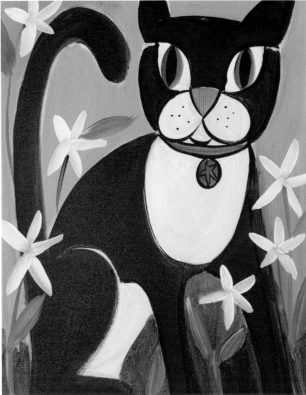

Outline the Face and Add Details

Load your no. 6 round with Dioxazine Purple and add two leaf-shaped pupils inside the green irises. Re-outline the eyes. Then outline the nose, jowls, mouth, collar and tag. You can put any shape or name you like inside the tag. And it can be any color you want! Wash and dry your brush.

Build Up the Background

Load your no.12 round with a little Dioxazine Purple. From the bottom of the painting up, add some purple to the background in the lower third of the painting. If you make upward strokes with the brush and then lift the brush off the canvas, you should get a nice, gentle blend between the purple and the blue. If that isn't happening, simply use your finger to blend the lines while the purple is still wet. Wash and dry your brush.

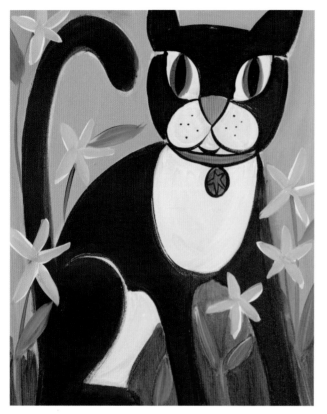

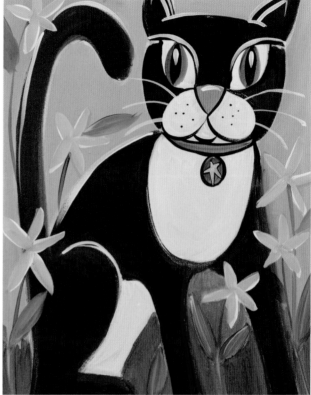

Paint Over the Flower Heads

Add some Hansa Yellow to your no.12 round and paint over the white of the flower heads. Wash and dry the brush.

Add Highlights

With Titanium White on your no.12 round, add highlights to the ears and top of the head, above the eyes, at the top of the nose, the tag, the back and the knee. The whiskers should be painted with the very tip of the brush. Make them quite long. (A cat's whiskers are about as long as the cat is wide.) Make sure the pupil is dry, then add a vertical white highlight to each eye. He should really be coming to life now! Wash and dry your brush.

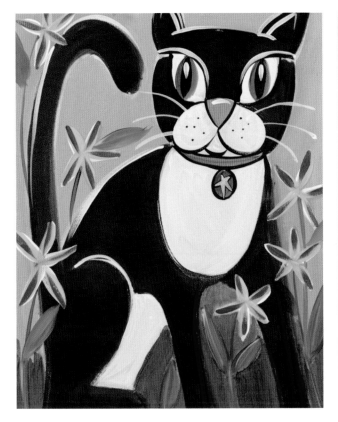

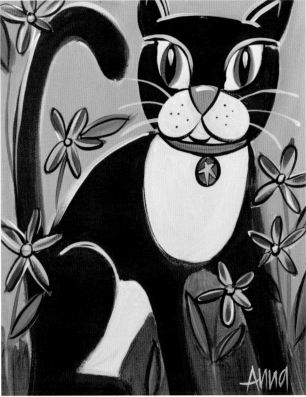

11

Build Up the Flowers

Still using your no.12 round loaded with Quinacridone Magenta, mark a line (stroking from the outside in) on each yellow petal. Wash and dry your brush.

12

Add Final Details to Finish

Load your no. 6 round with Dioxazine Purple and add a circle to the center of each flower. Then loosely outline each petal and leaf. Sign your name—you're done!

Visit artistsnetwork.com/paintingparty to download stencil templates and a bonus demonstration.

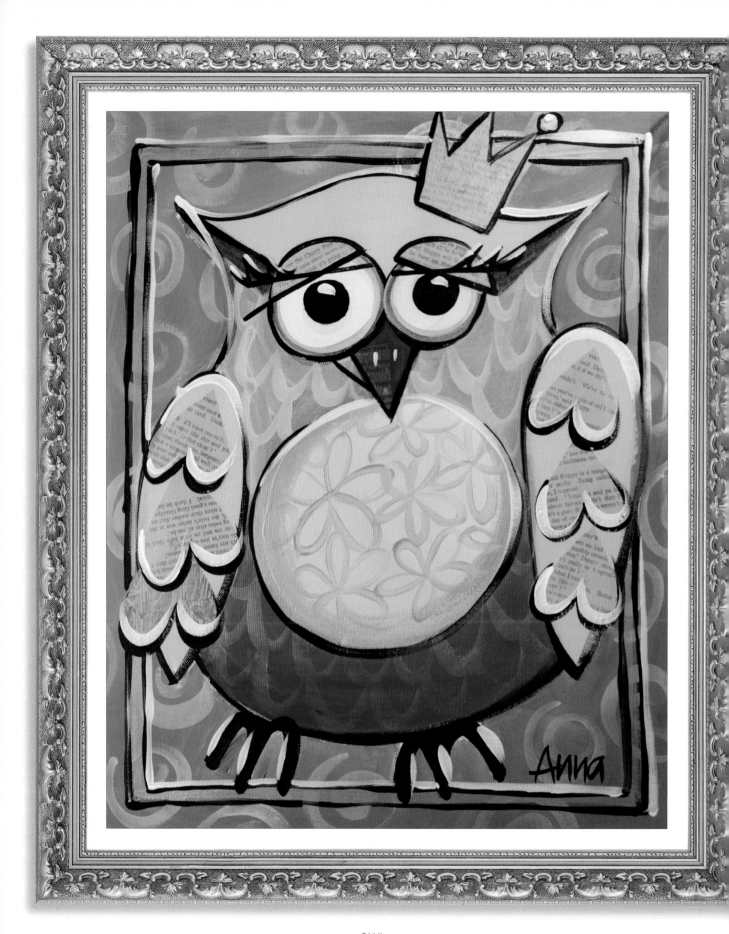

OWL
Acrylic on canvas
16" × 20" (40cm × 50cm)

OWL

This owl painting project demonstrates some basic glazing techniques, collage and painted collage. You will build this painting up in layers, so feel free to experiment with color options and different patterns in the background and on the belly. You can even have a heart-shaped belly instead of a circle if you like. It's completely up to you.

In this example, while the eyes are slightly different sizes, the irises in the center of each eye are the same size. And each eyelid is made of two crossed lines, like chopsticks. One line is angled, and one line is straight across the eye. There are three eyelashes on the end of each flat line. I also used gold as a metallic highlight in this example. Feel free to use silver or another metallic color if you prefer.

You could do your owl outlines in chalk first if you like, but I do like the unpredictability of putting paint to canvas. Please don't worry about trying to make your shapes exactly the same as in my example. Having slightly different proportions will give your owl a character all his own. You might even want to create an entire flock of personalities!

The owl in this painting is designed to fill up the whole space, with only limited background space and color. You may choose to make your owl smaller or turn the canvas on its side and do two owls. As long as you get some paint on your brush and practice, you'll become familiar with skills and techniques to add to your repertoire.

MATERIALS

Surface
- ❀ stretched canvas, 16" × 20" (40cm × 50cm)

Golden Fluid Acrylic Paints
- ❀ Dioxazine Purple
- ❀ Hansa Yellow Medium
- ❀ Iridescent Gold
- ❀ Quinacridone Magenta
- ❀ Teal (or Turquoise)
- ❀ Titanium White
- ❀ Ultramarine Blue

Brushes
- ❀ no. 12 flat
- ❀ nos. 6 and 12 rounds
- ❀ old flat brush (for collage)

Other
- ❀ chalk or charcoal
- ❀ book pages
- ❀ palette
- ❀ paper towel
- ❀ scissors
- ❀ Soft Gel Medium
- ❀ water

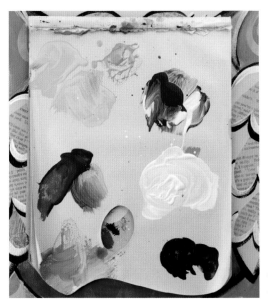

PALETTE FOR OWL

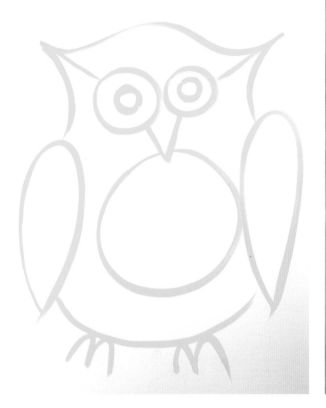

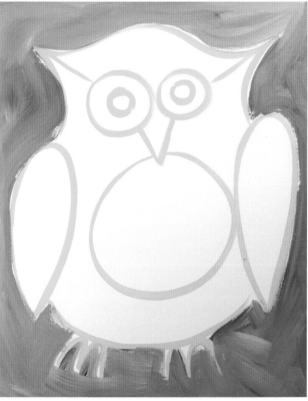

Outline the Composition

Load your no.12 round with Hansa Yellow Medium and paint the shapes that make up the owl. Deliberately try to fill up most of the space on the canvas—there will not be very much background color showing in this painting. Start with the eyes, about one-third of the way down the canvas. Make one eye slightly larger than the other, and place them so they are just barely touching. This avoids the difficult question of where the beak should finish. Add the V shape for the beak, the teardrop shapes for the wings (stay close to the sides of the canvas there) and a circle or heart shape for the belly (it should start at the beak). Then join all those lines together with the swoops for the top of the head, the lines to the ears, the curves where the ears join the shoulders of the wings, the curve under the tummy and the golden arches of the feet. Wash and dry your brush.

Lay In the Background

Load your no.12 flat with Titanium White and a little Ultramarine Blue and fill in the background. Don't worry about making your edges totally neat as they'll be covered up in later stages of the painting. Just give your arm a workout and get that paint on! Wash and dry your brush.

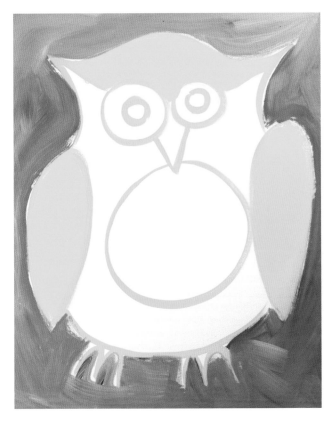

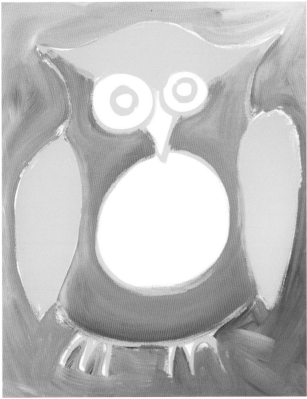

Fill In the Head and Wings

Load your clean, dry no.12 flat with Hansa Yellow and fill in the top of the head and the wings.

Fill In the Body

Without washing out your brush, load it with more yellow and just a smidge of Quinacridone Magenta. (You can always add more if you want it darker, but test it on the canvas first.) Fill in the body of the owl with this orange color. Wash and dry your brush.

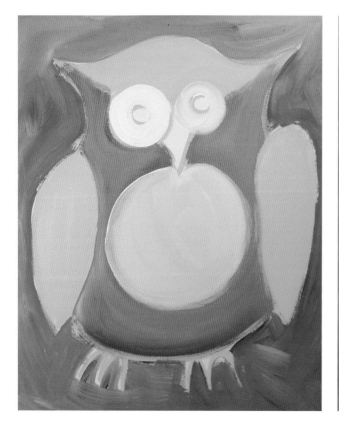

5

Fill In the Eyes and Belly

Still using the no.12 flat, fill in the whites of the eyes with Titanium White. Then add a little Hansa Yellow and fill in the belly shape. Wash and dry your brush.

6

Fill In the Beak

Switch to a no.12 round and fill in the beak with Quinacridone Magenta. Wash and dry your brush.

Receive bonus materials when you sign up for our free newsletter at artistsnetwork.com.

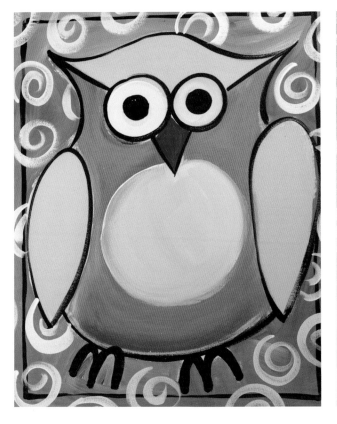

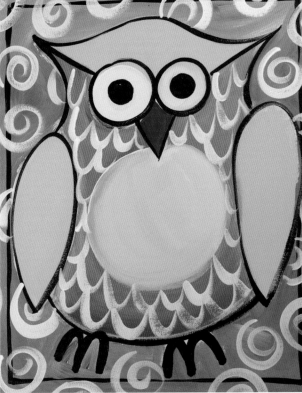

7

Outline the Owl and Add a Border

Load your no.12 round with Dioxazine Purple and paint the outlines of your owl. Then paint a rectangle border about 1" (2.5cm) in from the edge of the canvas. Just do it freehand—it doesn't have to be perfectly straight since you'll be painting over it again soon anyway. Wash and dry your brush, then reload it with Titanium White. Paint a pattern of white swirls across the blue background. This should be a wallpaper-like effect, so have some of the swirls just peeking around the edge of the owl and some going off the edge of the canvas.

8

Paint a Pattern on the Body

Using the same brush and Titanium White, paint a scalloped pattern across the owl's body to give the impression of feathers. Wash and dry your brush.

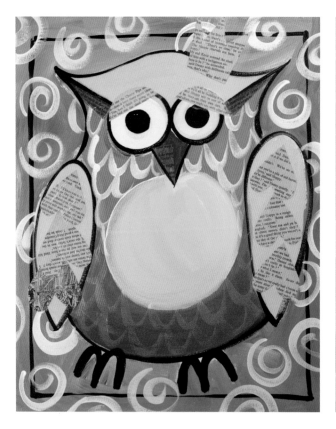

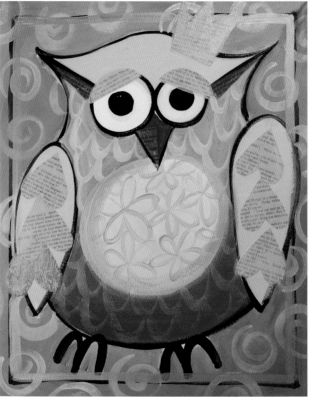

9

Add the Collage Elements and Apply a Glaze

Cut out the following shapes as simply or as elaborately as you wish: one crown, six hearts, two curved-top flat-bottom shapes (like the shape of orange segments) and three thin wedges (two for the ears and one for the beak). Remember, you'll be painting over them, so there's no need to measure anything exactly.

Use an old flat brush to completely cover each piece of paper with Soft Gel Medium on both sides. Adhere them to your painting where shown. (The beak and ear wedges are already painted over in my example.) These are quite small shapes, so hopefully you won't have any trouble with creases or bubbles. Leave your painting to dry. (You can use a hair dryer to speed up the drying process if you wish.)

Once the last layers are dry, load your no.12 round with Quinacridone Magenta and glaze over the bottom half of the owl's body. The white should show through and become pink. If your paint colors are not transparent enough and this doesn't happen, you could thin your paint with a little water. If that doesn't work, you may need to add a glazing medium. However, be sure to use some water too; otherwise it might stay sticky. Paint over the collaged ears and beak. You want to be able to see the texture of the text through the transparent paint. Wash and dry your brush.

10

Continue Building Layers and Glazing

Reload your brush with Hansa Yellow and paint a transparent layer of color over the collaged hearts on the wings, the eyebrows and the top half of the body. Wash and dry your brush.

Switch to a no.12 flat and paint a thinned-down glaze of Teal or Turquoise over the background blue and swirls. Wash and dry your brush.

Then switch back to a no.12 round and paint the crown with Iridescent Gold. Use a thin application of paint mixed with water so the text is still slightly visible. Bend the bristles of your brush to paint a line of gold over the rectangle border. Add a gold edge to the owl's belly and fill it in with a pattern. (I used a simple flower pattern in this example.) Finally, add a gold line around each eye. This will tone down the dark purple outline significantly. Wash and dry your brush.

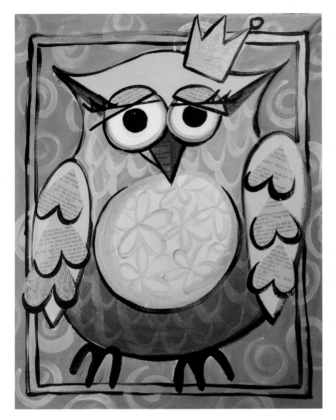

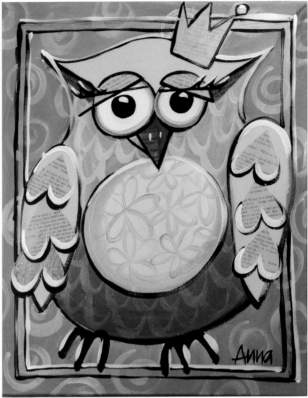

11

Outline the Owl, Collage Elements and Border

Reload your no.12 round with Dioxazine Purple and work your way down the painting, adding outlines to the crown, the border, the eyes (note the crossed lines on each eye), the beak (there is an extra angled line on the left side of the beak), the bottom of the belly and the bottom scallops of the upside-down hearts on the wings. Wash and dry your brush and let the painting dry.

12

Add Final Details to Finish

Load the same brush with Titanium White and work your way down the painting once again, this time adding highlights as you go. Add white to the border, to the dot at the top of the crown, across the top of the head and in the curves down from the ears, to the tips of the eyelashes, as a small curve in each of the eye pupils, two tiny nostrils, the top of the belly and the shoulders, the bottom of each of the wing hearts, and one side of each of the toes. Wash and dry your brush.

Now check back over your work and adjust or change anything that bothers you. (I added some extra gold to the crown dot.) Sign your name—this wise owl is finished!

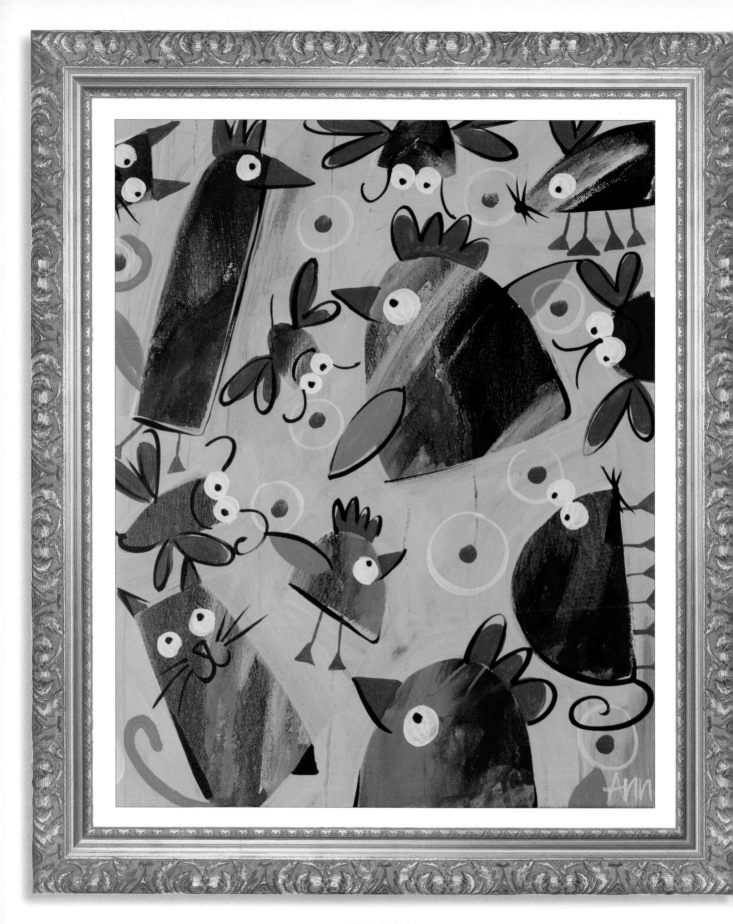

MENAGERIE
Acrylic on canvas
16" × 20" (40cm × 50cm)

May

S	M	T	W	T	F	S
1	2	3	4	5	6	7
8	9	10	11	12	13	14
15	16	17	18	19	20	21
22	23	24	25	26	27	28
29	30	31				

June

S	M	T	W	T	F	S
			1	2	3	4
5	6	7	8	9	10	11
12	13	14	15	16	17	18
19	20	21	22	23	24	25
26	27	28	29	30		

July

S	M	T	W	T	F	S
					1	2
3	4	5	6	7	8	9
10	11	12	13	14	15	16
17	18	19	20	21	22	23
24	25	26	27	28	29	30
31						

August

S	M	T	W	T	F	S
	1	2	3	4	5	6
7	8	9	10	11	12	13
14	15	16	17	18	19	20
21	22	23	24	25	26	27
28	29	30	31			

September

S	M	T	W	T	F	S
				1	2	3
4	5	6	7	8	9	10
11	12	13	14	15	16	17
18	19	20	21	22	23	24
25	26	27	28	29	30	

October

S	M	T	W	T	F	S
						1
2	3	4	5	6	7	8
9	10	11	12	13	14	15
16	17	18	19	20	21	22
23	24	25	26	27	28	29
30	31					

November

S	M	T	W	T	F	S
		1	2	3	4	5
6	7	8	9	10	11	12
13	14	15	16	17	18	19
20	21	22	23	24	25	26
27	28	29	30			

December

S	M	T	W	T	F	S
				1	2	3
4	5	6	7	8	9	10
11	12	13	14	15	16	17
18	19	20	21	22	23	24
25	26	27	28	29	30	31

MENAGERIE

Oh, how I love this painting! It's so simple, but so effective. You can really play with your colors in this piece, and indeed, the success of this painting rests with your color choices. So perhaps do a small study before you start your big painting, just to make sure you're happy with your colors. Or simply copy the colors you like from my example.

This is a wonderful subject to paint with children—even if they use a smaller canvas and only do one shape, they'll get a terrific result.

The most important thing in this project is to make sure your shapes are generous. You can always make your cat or chicken smaller if you need to, but it will be hard to make them bigger if you end up with too much yellow background.

You can also include text or collage in your background design if you wish. This is your opportunity to really make the artwork your own. (Even if elements get covered up as you layer on more paint, the fact that you know they are there underneath will make the painting extra special.) Have fun!

MATERIALS

Surface
- ✿ stretched canvas, 16" × 20" (40cm × 50cm)

Golden Fluid Acrylic Paints
- ✿ Carbon Black
- ✿ Dioxazine Purple
- ✿ Hansa Yellow Medium
- ✿ Pyrrole Red
- ✿ Quinacridone Magenta
- ✿ Teal (or Turquoise)
- ✿ Titanium White
- ✿ Ultramarine Blue

Brushes
- ✿ no. 12 flat
- ✿ nos. 6 and 12 rounds

Other
- ✿ chalk or charcoal
- ✿ palette
- ✿ paper towel
- ✿ spray bottle
- ✿ water
- ✿ white gesso

MENAGERIE
CHARACTER
SKETCHES

1

Prepare the Surface

Undercoat your canvas with white gesso using your no.12 flat.

2

Drip On Color

Drip some colors onto your canvas. I have used Ultramarine Blue, Dioxazine Purple, Quinacridone Magenta and Teal. You could do this with the canvas lying flat on a table or propped up on an easel.

3

Build Up Color

Using your no.12 flat and a spray bottle, start covering your
canvas with colors. Try not to mix (and muddy) them too much.
Keep as many areas as possible clear and clean colored.

4

Continue Building Color and Texture

Add some loose Titanium White and Teal lines across the canvas. It really is up to you how far you want to take this first layer of colors and textures—use stencils, fingerprints or even monoprint with bubble wrap. Just try to stay true to the colors you started with. If it does start too get muddy and isn't what you wanted, simply let your canvas dry and start again. Just don't allow too much white showing at the end, as this may distract from the eyes of your creatures.

Make sure your background is dry before you begin the next step.

5

Block In the Animal Shapes

Using my character sketches as a guide, paint a series of shapes on the canvas with Titanium White and your no. 6 round. If you are nervous about marking these shapes in with paint, you can use chalk first and then go over your lines with paint. You can also photocopy and enlarge my sketch examples to use as a template for your own creatures if you wish.

<div align="center">6</div>

Fill In the Negative Space and Add Texture

With your no.12 flat, lightly fill in the negative space between your shapes. At this stage you want to be able to see the brushstrokes as well as some of the colors from the bottom layer peeking through. So stay loose!

While the white background is still wet, use the end of your brush handle to scratch vertical lines through the white from the top to the bottom. This is called sgraffito and will add some lovely texture to your painting. Wash and dry your brush and make sure your background is dry before moving on to the next step.

<div align="center">7</div>

Add Another Layer of Color

Load your no.12 flat with Hansa Yellow Medium and a teeny bit of Pyrrole Red, then cover the white background that you have just painted. Because this yellow is transparent, you'll still be able to see the sgraffito lines through it. The touch of red will make orange in parts, also adding to the painterly look of the artwork. You want to try to avoid flat panes of color here.

8

Paint the Extremities

Load Pyrrole Red onto your no. 6 round and add beaks, crowns, wings, legs and feet to the body shapes. Then sprinkle some red fingerprint dots onto the yellow background. (I added eleven.) Wash and dry your brush.

9

Finish the Extremities

Using Teal and your no. 12 round, add wings and tails to the remaining creatures as needed. Wash and dry your brush.

10

Paint the Eyes and
Add Background Details

Load your no.12 round with Titanium White and add circles for eyes as shown. Then using the very tip of your brush, add a thin white circle around each of the red fingerprint dots. Wash and dry your brush.

11

Add Final Details to Finish

Load your no. 6 round with Carbon Black and add pupils to each eye and antennas to each bug. Add tails to the mice and whiskers to the cats' faces. Also add some black triangles to make cat feet if needed. Loosely outline the shapes and some of the wings. (A broken line of varying thickness is far more interesting than a solid line.) Finally, add curved smiles to all of your bugs and to the bottom of each beak so your menagerie of creatures looks super friendly. Sign your name—you're done!

Visit artistsnetwork.com/paintingparty to download stencil templates and a bonus demonstration.

TULIPS

Acrylic on canvas

16" × 20" (40cm × 50cm)

TULIPS

Tulips are a very identifiable flower, and because my hometown has so many on display during our Carnival of Flowers each August, I knew I'd have to add them to the paint-along calendar early on.

Before you begin, there are a few things to note about tulips. The first is the way their petals sit on each other. They don't wrap around like a rose—they're either inside or outside. They also have very thick, juicy stems and long, flat leaves.

I like to think of a tulip's shape as a wine glass, and I've found this is the best way to explain how the stem joins to the flower head. It is a 90-degree angle, a T junction. Make sure you're not sending your stem off in a weird direction.

Your background really can be any color you like, but I'm partial to using a mid-blue or gold for this project. (Gold is a terrific choice for a neutral-colored house.)

Remember that your goal here is not to paint a botanical specimen. These tulips may be inspired by real life, but they don't have to be painted exactly like real life. Just have fun!

MATERIALS

Surface
- ✿ stretched canvas, 16" × 20" (40cm × 50cm)

Golden Fluid Acrylic Paints
- ✿ Carbon Black
- ✿ Dioxazine Purple
- ✿ Hansa Yellow Medium
- ✿ Iridescent Gold
- ✿ Jenkins Green
- ✿ Pyrrole Red
- ✿ Sap Green
- ✿ Titanium White
- ✿ Ultramarine Blue

Brushes
- ✿ no. 12 flat
- ✿ nos. 6 and 12 rounds

Other
- ✿ chalk or charcoal
- ✿ palette
- ✿ paper towel
- ✿ water

ALTERNATE COMPOSITION

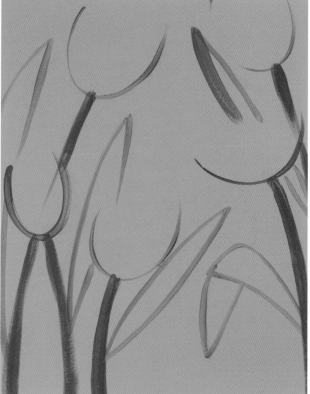

Prepare the Surface

Use a no.12 flat to undercoat the whole canvas with Hansa Yellow Medium.

Block In the Flower Shapes

Load your no.12 round with Sap Green and paint five U shapes for the flower heads. All should be at slightly different heights and angles. Be sure not to put one slap bang in the middle! Add stems for each flower. The stem joins at the bottom of the U shape. Imagine them as wine glasses to get a better understanding of the shape.

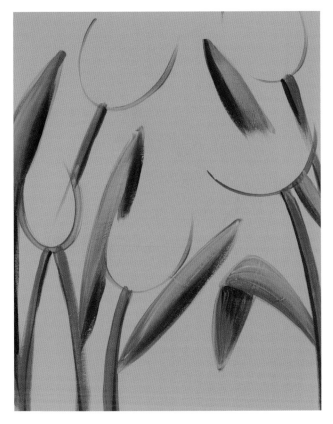

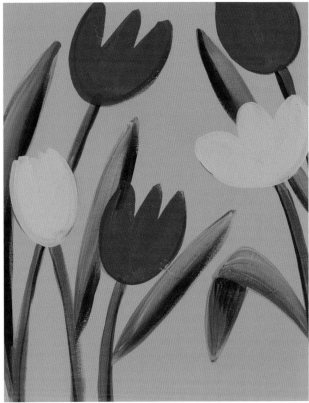

3

Paint the Leaves

Tulip leaves are long and flat. With the same brush and color you used in the last step, add a leaf to every stem. Make sure one leaf is folded over by using two triangles as shown.

Continue using Sap Green to fill in the leaves by bending the bristles of the brush and using a minimal number of strokes. There is no need to paint through the flower heads—try to leave them empty. While the leaves are still wet, pick up some Hansa Yellow on your brush and paint half of each leaf yellow. Use your whole arm and you should get a nice blend.

Without washing out your brush, pick up some Jenkins Green. Add to the other side of each leaf and paint a thin line on the underside of each stem. Wash and dry your brush.

4

Paint the Flower Heads

Load up with Titanium White and paint two tulip heads. Then wash and dry your brush and paint three more tulip heads with Pyrrole Red. Make the top right tulip go right off the edge of the canvas. Wash and dry your brush.

5

Lay In the Background and Build Up the Flowers

Load your no.12 flat with Titanium White and a small amount of Ultramarine Blue. Lay in the background, leaving some yellow around the flowers, stems and leaves. It's nice to see some brushstrokes here—it doesn't need to be flat color. Be sure to paint all your edges as well. Wash and dry your brush.

Switch to a no.12 round and Titanium White. Paint petal lines on two of the red flower heads. Wash and dry your brush, then load up with Quinacridone Magenta. Paint thin lines on the underside of each leaf as shown. Add some Magenta to the base of each flower head with just a little Magenta mark underneath each one, making a shadow at the top of each stem. Add some Magenta strokes at the top of the triangle that is the underside of the folded leaf (as pictured). Paint one of the white tulip heads Hansa Yellow Medium. Wash and dry your brush.

6

Add Some Shadow Leaf Shapes

With Dioxazine Purple on your no.12 round, add about seven more leaf shapes (shadows). This will start to fill up the canvas, but remember to leave some yellow peeking through from the background. Don't be too neat! Wash and dry your brush.

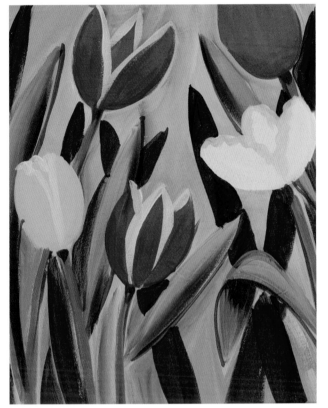

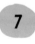

Clean Up the Leaves and Continue Building Up the Flowers

Pick up some Sap Green with the same brush and repaint your stems, taking a moment to tidy up any leaves if needed. Wash and dry your brush, then reload it with Iridescent Gold. Paint some wavy lines on the edges of the white tulip. Wash and dry the brush again, then add some white lines to the yellow tulip head.

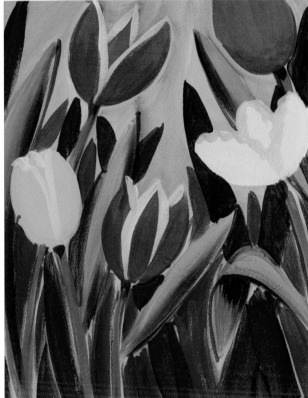

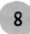

Add More Leaf Shadows

Using your no.12 round and Quinacridone Magenta, add in more leaf shadows to fill up the spaces at the bottom in between the existing leaves, stems and leaf shadows. Remember to try to keep them on slightly different angles and make them slightly different heights. Some yellow background color should still be peeking through. If it isn't, you might need to add some yellow strokes back in next to your green stem edges.

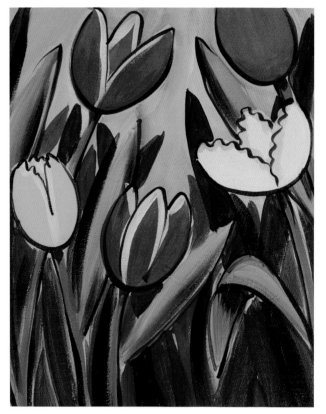

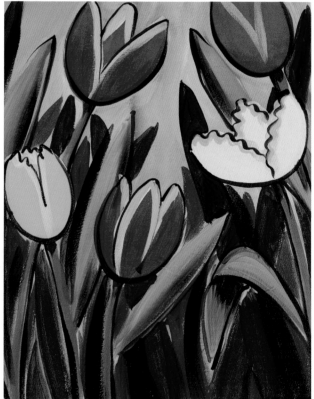

9

Continue Adding Shadow Leaves and Outline the Flowers

Without washing out your brush, pick up a little Carbon Black and add five more leaf shadows. Wash and dry your brush.

Switch to a no. 6 round. With Dioxazine Purple, loosely outline all five flower heads and the low side of each green leaf and stem. Your painting will be looking pretty dark at this stage, but don't panic. Wash and dry your brush.

10

Continue Detailing the Flowers

Using Hansa Yellow Medium and your no.12 round, paint over the white edges of the two red tulips and add some lines to the top red flower. Wash and dry your brush. Then, to make the yellow you just used a little less stark, load your brush with Iridescent Gold and go over the yellow petal lines on all three of the red tulips. Wash and dry your brush.

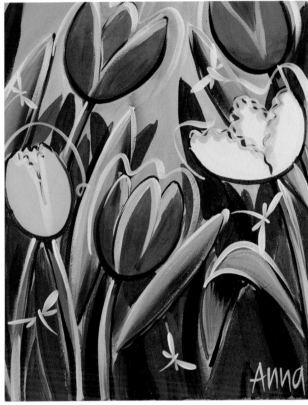

<div align="center">

11

Add Highlights

</div>

Using Titanium White and your no.12 round, add some highlights to the top side of every green leaf. Then add some white lines about ¾" (1cm) above the edge of each flower head as loose action marks. (If you are naturally heavy-handed, you should use a no. 6 round for this instead.)

With the white still on your brush, ensure your purple outlines are dry and then lightly paint over those dark purple lines in the yellow and white flower heads.

<div align="center">

12

Add Final Details to Finish

</div>

To add some interest and fill any dark gaps, add either three or five little dragonflies (each flying at a different angle) to the painting. Then add some gold lines to each green leaf and stem, just below the white highlight lines.

Take a step away from the painting and evaluate your work. Touch up any areas that may need neatening if they bother you. Sign your name!

FLYING HEARTS

Acrylic on canvas

16" × 20" (40cm × 50cm)

FLYING HEARTS

This is the composition from the very first advertised paint-along I ever ran. It is beguilingly simple, and you will be able to make this painting special with some wet-into-wet painting. You can choose the number of hearts you want to include in your composition, and it will work equally well as a vertical (portrait) or horizontal (landscape) orientation. You also can't go wrong with the color combination of Teal and Pyrrole Red. Add a touch of black and white, and we have a winner! As the project progresses, you'll add lovely loose details to build interest and pattern.

You will jump around a bit with this painting—from the background to the foreground and then back again. This is simply to allow you to keep working on certain areas of the painting while other areas are drying as needed.

MATERIALS

Surface
- ✿ stretched canvas, 16" × 20" (40cm × 50cm)

Golden Fluid Acrylic Paints
- ✿ Diarylide Yellow
- ✿ Dioxazine Purple
- ✿ Pyrrole Red
- ✿ Quinacridone Magenta
- ✿ Teal
- ✿ Titanium White

Brushes
- ✿ no. 12 flat
- ✿ nos. 6 and 12 rounds

Other
- ✿ chalk or charcoal
- ✿ palette
- ✿ paper towel
- ✿ water
- ✿ white gesso

FLYING HEARTS
PALETTE

1

Prepare the Surface

Undercoat your canvas with white gesso.

2

Sketch the Composition

Using chalk or charcoal, sketch one large heart and a number of smaller hearts around it. (I added five smaller hearts.) Next add the wings—my wing shape is essentially three "fingers" angled upward. I love the simplicity of them!

Receive bonus materials when you sign up for our free newsletter at artistsnetwork.com.

3

Lay In the Background

Using a no.12 flat, fill in the entire background with Teal mixed with a small amount of Titanium White. Let the brushstrokes show.

4

Build Up the Background

While that first background layer is still wet and without washing out your brush, add some strokes of Ultramarine Blue + Titanium White to the lower third of the background. Wash and dry your brush.

Visit artistsnetwork.com/paintingparty to download stencil templates and a bonus demonstration.

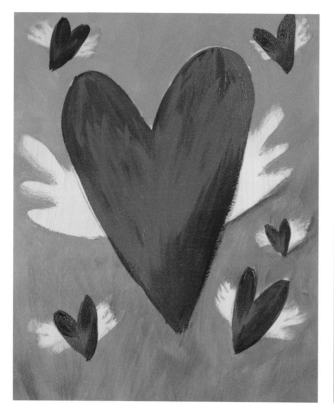

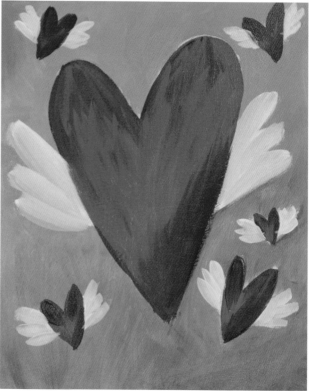

5

Paint the Hearts

Load a clean, dry no.12 flat with Pyrrole Red and paint all of your hearts. Once again, brushstrokes are allowed!

While the hearts are still wet and without washing out your brush, add some Quinacridone Magenta to the top bumps and blend downward. Then go to the bottom point and blend upward. Wash and dry your brush before adding a little bit more Ultramarine Blue + Titanium White to the top left corner of the canvas. Wash and dry your brush.

6

Paint the Wings

Load up your clean, dry no.12 flat with Titanium White, picking up a bit of Diarylide Yellow on one side of the brush as well. Paint the wings with this color combination. (If your blue background is still wet, you might need to blow dry the painting first.) Wash and dry your brush.

 7

Build Up the Hearts and Outline the Wings

Switch to a no.12 round and outline all of the hearts and wings in Dioxazine Purple. You want to use this color as a dark, not necessarily a purple, so really load up your brush by stroking it on the palette.

 8

Add a Border

With that same brush, add a broken-line border around the sides and top of the composition, breaking the line with some irregular marks as shown. Across the bottom of the canvas and at a slight angle, add a thin rectangle of purple, and color in wide bars with the dark purple. Wash and dry your brush and wait for this color to dry before moving on to the next stage. (You can use a hair dryer to speed up the drying process if you wish.)

Visit artistsnetwork.com/paintingparty to download stencil templates and a bonus demonstration.

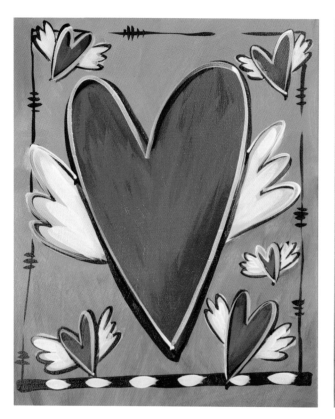

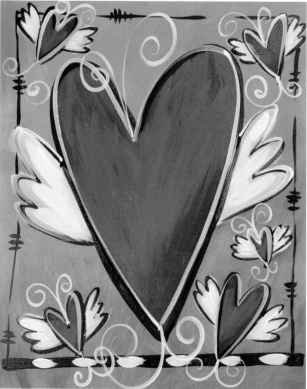

 9

Outline the Hearts and Wings with White

Reload your no.12 round with Titanium White and outline all of the hearts and wings. Fill in the spaces in the bottom bar as well. Stay loose! A varied line is far more interesting than a consistently even one!

 10

Add Swirls

With the white still on your brush and using the very tip of the bristles, add long swirls to each heart, springing from the center dent and the pointed tail of each. It's really important to stay loose here, so practice on something else if you need to get a feel for the spiral shapes. Try to make them slightly different sizes on each side (i.e., not symmetrical).

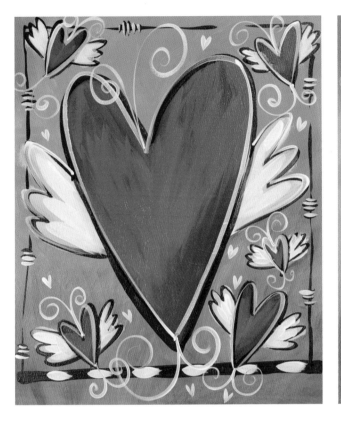

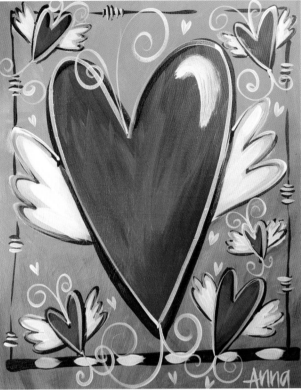

11

Add More Hearts and Highlights

With the same brush and more Titanium White, add some small V-shaped hearts to fill in spaces. (I have used nine.) Then add a highlight to each of the marks that broke your original border line.

12

Add Final Details to Finish

Using your no.12 flat, add a loose curve of white to the top right curve of the main heart.

Then switch to the no.12 round. With Diarylide Yellow and a little bit of Titanium White, loosely outline each wing and fill in one space on the bottom bar with yellow over the white that is already there.

Step away from your canvas and take a good look before you touch up any areas that may need neatening or adjusting. When you're happy with it, sign your name!

My hope for you is that you have a go at any of the projects in this book that take your fancy. If you're the type of person that needs to finish the lot, by all means, go for it! But otherwise please, feel free to pick your favorites. I'll be so happy just to know that you've picked up a brush!

Take what you learn from following my steps and make a few changes here and a few changes there… experiment with different colors and shapes, mixing and matching. Think about the subjects that you are drawn to and then take what you've learned and have at it. The more you practice and the closer you come to aligning what you want to paint with the style you want to paint it in, the sooner you'll find your signature style.

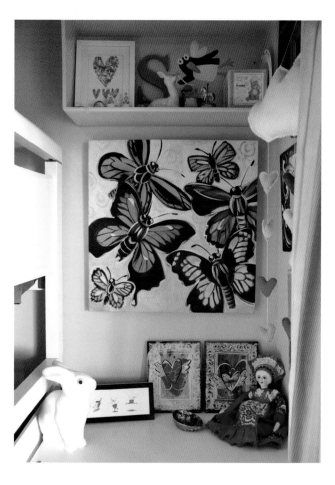

Dale Carnegie wrote, "One reason why birds and horses are not unhappy is because they are not trying to impress other birds and horses." Remember you don't have to compare yourself to anyone else. We are all on our own art journey—even the way I teach in this book is simply my own way of doing things.

I very much enjoy sharing the way I make art because it makes me happy. I hope it makes you happy as well. There are so many books and online courses available these days, you're bound to find a style that makes your imagination soar. And you'll get better the more you practice.

Because the projects in this book are based on my own style, it's important that you take what you've learned from me along with other artists and influences and practice enough to develop your own style—especially if you plan to sell your art.

Of course, displaying your pieces in your home or gifting them is absolutely fine. But if you do decide to publicly display or sell your paintings based on any of the projects in this book, please give proper credit such as, "Your Title, based on a tutorial by Anna Bartlett," or "Inspired by the work of Anna Bartlett." Thanks so much.

If you like what you see here, come and visit me online at shinyhappyart.com. I offer a selection of online courses and paint-alongs, and I'd love to have you join in and keep painting.

INDEX

METRIC CONVERSION CHART		
To convert	*to*	*multiply by*
Inches	Centimeters	2.54
Centimeters	Inches	0.4
Feet	Centimeters	30.5
Centimeters	Feet	0.03
Yards	Meters	0.9
Meters	Yards	1.1

Receive bonus materials when you sign up for our free newsletter at artistsnetwork.com.

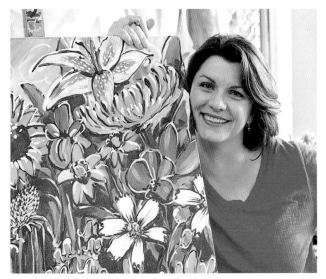

a content + ecommerce company

Other fine North Light Books are available from your favorite bookstore, art supply store or online supplier. Visit our website at fwmedia.com.

20 19 18 17 16 5 4 3 2 1

DISTRIBUTED IN CANADA BY FRASER DIRECT
100 Armstrong Avenue
Georgetown, ON, Canada L7G 5S4
Tel: (905) 877-4411

DISTRIBUTED IN THE U.K. AND EUROPE
BY F&W MEDIA INTERNATIONAL LTD
Brunel House, Forde Close, Newton Abbot, TQ12 4PU, UK
Tel: (+44) 1626 323200, Fax: (+44) 1626 323319
Email: enquiries@fwmedia.com

DISTRIBUTED IN AUSTRALIA BY CAPRICORN LINK
P.O. Box 704, S. Windsor NSW, 2756 Australia
Tel: (02) 4560-1600; Fax: (02) 4577 5288
Email: books@capricornlink.com.au

ISBN 13: 978-1-4403-4126-7

Edited by Christina Richards
Designed by Breanna Loebach
Production coordinated by Jennifer Bass

ABOUT THE AUTHOR

Anna Barlett is a colorful, modern artist who lives in a long house on a foggy mountain top in Toowoomba, Queensland, Australia. Having always loved to draw and paint, she made and sold hand-painted handbags for three years (more than 500 were sold), which helped her learn how to paint very quickly.

Anna's superpower is making things simple. She started Shiny Happy Art in 2003 and has built a solid blog following. She rolled out the paint-along side of Shiny Happy Art in December 2011. Since then she has welcomed more than 500 people to paint in her studio, with her painting sessions selling out months in advance.

Anna is also the Marketing and Development Manager at Downlands College. You can find her online at:

shinyhappyart.com

annabartlett.com.au

facebook.com/ShinyHappyArt

DEDICATION

To my five favorite works of art and to Mrs. Wheatley, who taught me how to use apostrophes.

ACKNOWLEDGEMENTS

Thanks to James, Josh, Sophia and Beth for being such happy and talented kids and for assisting me with paint-alongs and helping string paintings and set up easels. You guys are great.

Thanks to David for working so hard and doing so much folding and cooking for the past two years. You're lovely.

Thanks to my amazing Mum for making art a part of our lives from the very beginning, and to Dad for insisting I get a business degree.

Thanks to Lauren, Steffi, Robyn and Leisa for being my first enthusiastic supporters, and to the lovely Debbie, Mary, Bernie, Jude, Kym, Lyn, Lisa, Jeanette, Mikey, Jono, Erin, Peta, Peter and Whitney for being my number-one fans.

Thanks to Amber, Cassandra, Juanita, Suzanne, Jacqui and Kate who have helped me as both beautiful assistants and as friends. Thanks to Richard for filming, Mel for photographing, Suzanne for being my very first International Sales Manager and to Jo for being there at the beginning of this book dream.

Thanks to Tracy Verdugo, Georgia Mansur, Claire Bowditch and Jane Davenport who have paved the way for modern Australian artists and creative entrepreneurs.

Special thanks to all the paint-alongers who have joined me in my red-door studio and to those who have painted with me online. Your enthusiasm and encouragement is so appreciated. I love seeing what you paint and how wide it makes you smile—every time.